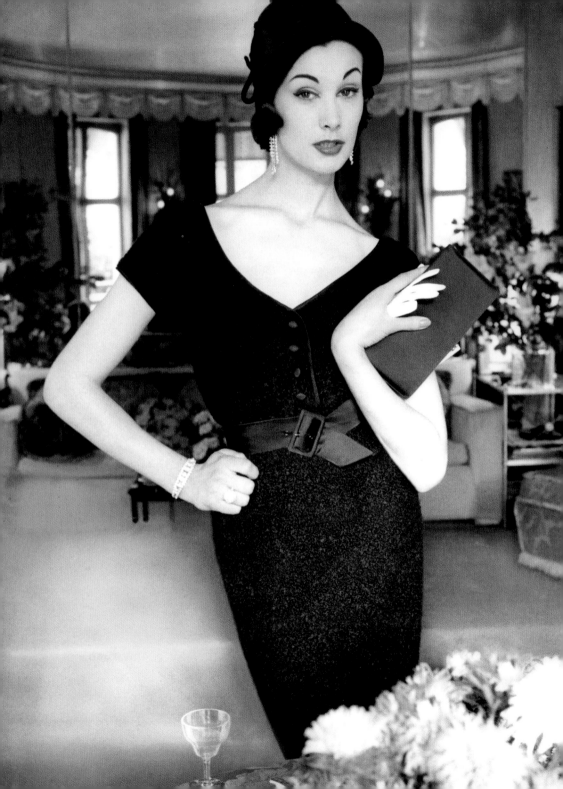

little black dress

Chloe Fox

conran
OCTOPUS

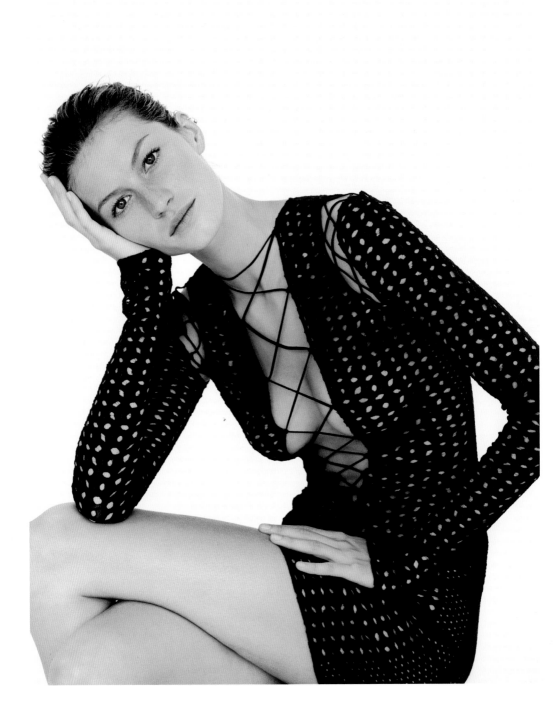

contents

introduction

fashion's best friend

When a simple, short black dress, designed by Coco Chanel, appeared in American *Vogue* in 1926, it was dubbed "Chanel's Ford". Like the Model T, Henry Ford's popular car of the time – available in every colour "so long as it is black" – the inimitable French couturier's design was hailed as accessible to women of all classes. The dress, announced *Vogue*, was a "sort of uniform for all tastes... the frock that all the world will wear".

How right they were. Today, almost a century later, the Little Black Dress – or LBD to its army of admirers – is the most dependable, go-to item in any woman's wardrobe. Loved as much for its versatility as for its figure-flattering powers, the LBD transcends age, size and occasion. Dressed up or down, the perfect LBD is the fashionable woman's best friend. As Wallis Simpson, a passionate advocate of the LBD, so elegantly put it, "When the little black dress is right, there is nothing else to wear in its place."

But it was not always thus. Black was traditionally the colour of mourning – women were expected to wear it for at least four years after the death of their husbands – and it was considered a shockingly risqué choice of colour for any self-respecting woman. When John Singer Sargent's *Portrait of Madame X* was first shown to the Paris Salon in 1884, with its subject, Madame Pierre Gautreu, wearing a revealing black satin dress with jewelled straps, it caused outrage.

It wasn't until World War I that wearing black in public became socially acceptable across the board. Not only did black express the collective grief and devastation caused by the war,

→ All hail John Galliano, master of the magnificent! A year before his ill-judged, anti-Semitic outbursts and his dismissal from Dior as creative director, the Gibraltar-born plumber's son and, arguably, one of the UK's greatest fashion designers, saw this Little Black Dress design for Dior featured in the February 2010 issue of *Vogue*. A strapless, corseted, lace-tiered chiffon dress, it is pure Galliano, referencing its own past and yet planting a flag firmly in fashion's future. This is everything the LBD can be: classic, sensual, playful, feminine and immensely flattering. Photograph by Daniel Jackson.

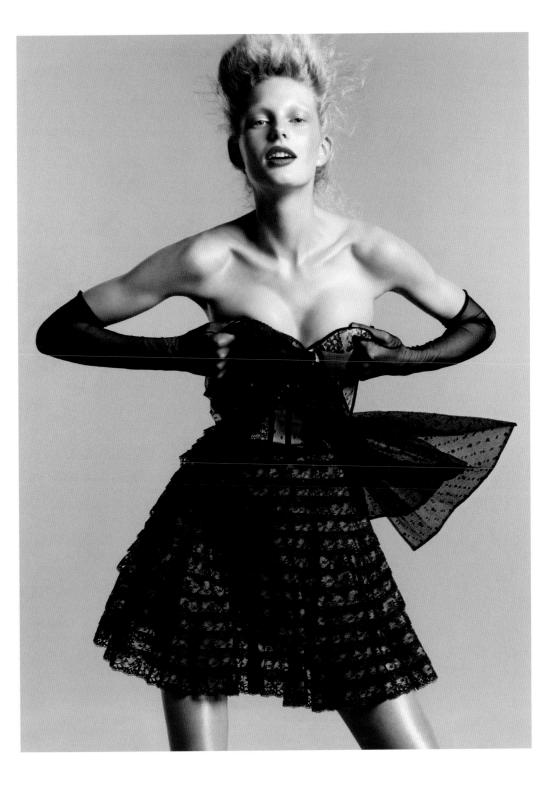

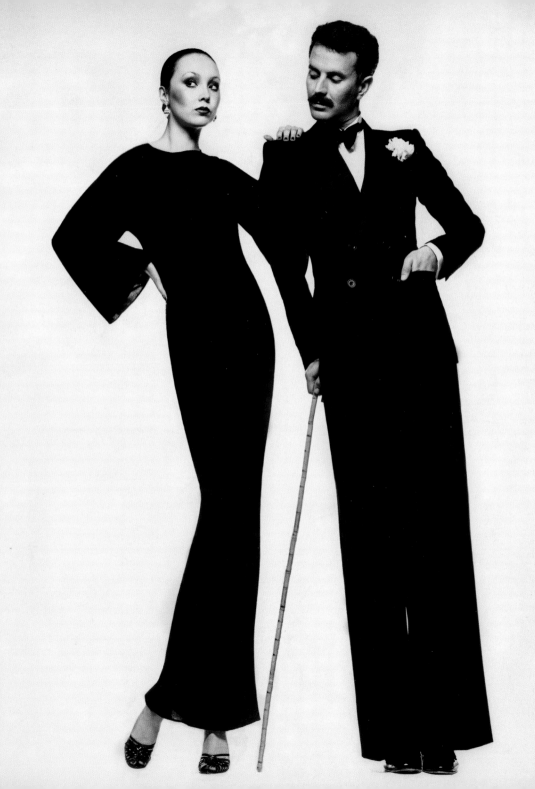

↑ For the October 1973 cover, legendary photographer Helmut Newton photographed the American model and actress Marisa Berenson – whom the fashion designer Yves Saint Laurent dubbed "The Girl of the Seventies" – in a simple black crepe Chloé dress outlined with diamanté. The image is pure Seventies chic: windblown hair, heavy eye make up and shimmering disco glamour. The dress itself has LBD star power, packing a party punch in the most undemonstrative way. With just a little sparkle added, you're ready for the dance floor.

← "We had a lot of fun on this photoshoot," recalls shoemaker extraordinaire Manolo Blahnik. In this September 1975 image by David Bailey, Blahnik appears with the photographer's then girlfriend, Tokyo-born American model Marie Helvin. A fledgling shoe designer of considerable talent, Blahnik was also very much the handsome man about town, although he claimed he looked like "a Mexican waiter" in this picture. Helvin wears a jersey tube dress with bell-sleeves by Bruce Oldfield, with the neckline slit low at the back.

it was also utilitarian. Darker shades were more practical at a time when increasing numbers of women were working outside the home for the war effort and getting dirty in the newly industrial world. Writing to a friend in 1920, the Polish-French physicist Marie Curie, famous for her pioneering research on radioactivity, remarked, "I have no dress except the one I wear every day. If you are going to be kind enough to give me one, please let it be practical and dark so that I can put it on afterwards to go to the laboratory."

The Little Black Dress might have cut a radically modern figure but, disregarding convention as she always did, Chanel helped to make it a part of every fashion-conscious woman's wardrobe. Among those displeased at the turn of events was the couturier Paul Poiret, who is said to have sniped at Chanel in the street with: "What are you in mourning for, Mademoiselle?" Her scissor-tongued retort is reputed to have been, "For you, dear Monsieur."

After Chanel broke the mould of women's fashion in the Twenties, the Little Black Dress went from strength to strength. During the Great Depression, the garment's economy and elegance – a typical Twenties LBD required only 1.8m (2 yards) of fabric as opposed to the 9m (10 yards) or more necessary to fashion the bustles and trains of yesteryear – made it indispensable to fashionable women the world over.

The LBD gained an insurmountable foothold in Hollywood. In 1927, a year after its appearance in American *Vogue*, the young Hollywood costumer Travis Banton created an iconic moment in women's fashion when he gave the Little Black Dress its cinematic debut. He dressed Clara Bow in one for her role in the hit film *It*. Bow, the biggest star in Hollywood at the time, played Betty Lou, a shop assistant on a lingerie counter in a major department store. In an attempt to impress her boss, she agrees to a date at the Ritz with his best friend, Monty. Betty doesn't have much to wear and, in a moment of madness, with the help of her flatmate, she transforms her demure black work dress into a daring evening frock. The effect of the scene in which the Little Black Dress first enters the Ritz cannot be underestimated. Overnight, the impact of the dress was cemented in people's minds. Later that same year, the LBD reached iconic levels of fame when Bow wore another version in her next movie, *Rough House Rosie*.

By the end of the Twenties, as Technicolor films became more popular, filmmakers relied increasingly on Little Black Dresses because they didn't clash with the other colours on the screen.

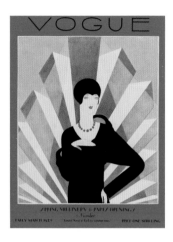

Since time immemorial, fashion and celebrity have been close bedfellows, and for more than almost any equivalent item of clothing, the increase in popularity of the LBD can be directly linked to the profiles of the women who wore it. When, in 1935, the singer Édith Piaf was discovered in the Pigalle area of Paris by nightclub owner Louis Leplée, he taught her the basics of stage presence and also told her to wear a black dress at all times. With that, her iconic look was born.

During World War II, the widespread rationing of textiles, coupled once again with the need for civilian women to have practical workwear solutions, made the LBD even more essential than ever. While standard daytime wear was "the Utility suit", only women of greater means could afford a separate evening frock. Thankfully, for fashionable women on both sides of the Atlantic, the LBD lent itself naturally to accessorizing. With a carefully chosen hat or piece of jewellery, it could be transformed into something infinitely more glamorous.

The end of World War II ushered in a new era of post-war glamour. On 16 December 1946, in a private house at 30, avenue Montaigne, in Paris, a young fashion designer named Christian Dior established the House of Dior with the backing of a wealthy businessman, Marcel Boussac. This event was to usher in a new period in the history of fashion: the birth of the "New Look", a refreshing antidote to austerity with an emphasis on the nipped-in silhouette and an extravagant use of fabric. Dior's little black creations – and he was certainly far from averse to working in black fabrics, particularly if they were velvet or satin – were usually characterized by their lavish full skirts and wasp waists, although the designer would, over time, begin to narrow his silhouette. "You can wear black at any time," he said. "You can wear black at any age. You can wear it on almost any occasion. A little black frock is essential to a woman."

In 1952, a talented young designer named Hubert de Givenchy allegedly turned down a job offer from Christian Dior and opted to open his own fashion house instead. He was 24 years old. Two years later, a young actress called Audrey Hepburn went, at the behest of legendary Hollywood costume designer Edith Head, to meet with Givenchy to discuss looks for her forthcoming role in Billy Wilder's romantic comedy *Sabrina*. Over multiple fittings, a friendship blossomed. While it is uncertain which of the film's array of beautiful costumes – including a full-skirted, silk LBD

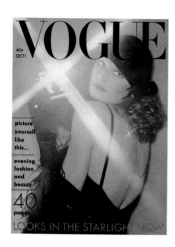

with a perfect, pinched-in waist – can be credited to Givenchy, he certainly never received the recognition he deserved. When Head accepted her Academy Award for her work on *Sabrina*, she didn't mention the young French designer at all. Hepburn was allegedly furious and vowed from that time forward to make films only in which she could appear in Givenchy's creations.

In 1961 Givenchy designed a Little Black Dress for the opening scene of Blake Edwards's romantic comedy *Breakfast at Tiffany's*. Widely considered to be one of the most iconic dresses of the 20th century, it has also been variously described as the most famous LBD of all time. A sleeveless, black, Italian satin sheath evening gown, it had a fitted bodice and was embellished at the back with a distinctive cut-out décolleté. The skirt itself was slightly gathered at the waist and slit to the thigh at one side. As well as designing the dress itself, Givenchy also provided the accessories – a pearl choker of many strands (designed by Givenchy jewellery designer Roger Scemama), a 30cm- (1ft-) long cigarette holder, a large black hat and opera gloves – which transformed the plain black dress into the stuff of legend. After Hepburn's death in 1993, Givenchy donated the black satin gown to the charity City of Joy Aid, and in 2006 the dress was auctioned at Christie's for £467,200 ($923,187 at the time).

The intense period of sartorial change ushered in by the Sixties has since come to be viewed as akin to a revolution. With the income of young people at its highest since the end of World War II, an increased economic power fuelled a new sense of identity and a need to express it. The fashion industry quickly responded by creating designs for young people that no longer simply copied "grown-up" styles. As hems became shorter and colours brighter, the LBD struggled to find its place in the psychedelic youth explosion. That said, by continuing to hold favour with a timeless few, it never quite lost its foothold. First Lady Jackie Kennedy wore hers particularly well, often accessorizing with a dramatic bouffant, a pair of oversized dark glasses and a string of pearls.

As the decades progressed, the LBD held firm, shifting and morphing to suit the sartorial mood of the times. Seventies rock chicks such as Debbie Harry wore theirs short in skintight leather. Embraced by punk-rock culture, the LBD began to be ripped, pinned and patched, a trend that was continued well into the Eighties by rebellious style icons such as Madonna. During the Nineties – a period that has since come to be characterized as the

↑ **"Picture Yourself Like This",** **announced the October 1974** **cover of *Vogue*, as shot by the** **legendary Italian photographer** **Oliviero Toscani (best known** **for his controversial advertising** **campaigns for Benetton in the** **Eighties). Featuring a model with** **her back to the camera, and a** **camera in her hand, it appears** **modern in more ways than one.** **The model seems to be taking** **a "selfie", some four decades** **before they would become the** **craze. The dress itself – a low-** **backed, spaghetti-strapped,** **black georgette design with** **chiffon handkerchief points, by** **Bellville-Sassoon – is timeless** **in its simplicity. But the flash** **of a diamond necklace, worn** **down the model's back, makes** **it feel fresh and just the tiniest** **bit mischievous.**

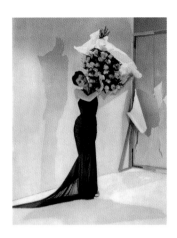

decade of grunge – the LBD reverted back to its plain and simple origins. Short, tight and powerfully feminine, it once again proved to be the perfect weapon for liberated womanhood. This was never better epitomized than on two standout occasions in 1994: first, at the premiere of *Four Weddings and a Funeral*, when Elizabeth Hurley's choice of a barely-there, safety-pinned Versace LBD meant nobody was looking at the star of the film, her boyfriend Hugh Grant, and second, and most memorably, at the Serpentine Gallery, when Princess Diana wore an off-the-shoulder and figure-hugging Christina Stambolian "Revenge Dress" on the eve of her husband's televised admission of an adulterous relationship with Camilla Parker Bowles.

For all its powers of flattery and impact, the real beauty of the Little Black Dress is its ability to be whatever the wearer wants, or needs, it to be. Demure or daring, dressed up or pared down, the LBD is the perfect blank canvas on which to define one's unique womanhood. At one and the same time, it can enhance features while concealing imperfections. The Little Black Dress has also managed to adapt to all socio-political changes and it is for this reason, as much as any other, that every designer worth their salt over the past century has entered wholeheartedly into fashion's constant, ever-evolving quest for the perfect version. Indeed, the LBD has become a rite of passage for generations of designers. As Miuccia Prada so succinctly put it in her introduction to the catalogue for a 2013 exhibition dedicated to the LBD from André Leon Talley (American *Vogue*'s former contributing editor): "To me, designing a little black dress is trying to express in a simple, banal object, a great complexity about women, aesthetics and current times." Coco Chanel could not have put it better herself.

↑ This opening image in a roundup from the Paris collections appeared in the September 1936 issue of American *Vogue*. Its photographer, Cecil Beaton, who had begun his career as a cement merchant in London's Holborn, was 32 years old and the brightest light in the Condé Nast magazine firmament. The image itself is pure Beaton, timelessly beautiful but with a nod to modernity and to its own constructed nature in the ripped backdrop. The model wears a black silk jersey halterneck dress by Alix, draped beautifully around the hips and with a sheer train.

→ By the late Eighties, the LBD had become shorter, tighter and generally more structured than in the previous decade. It was the calling card for most of the biggest design names in fashion, one of whom was Moroccan-born Joseph Ettedgui. In this photograph by Hans Feurer (March 1987), the model wears a black leather bolero and a black chiffon bra, lined with satin and caught to a gathered web of a black lace skirt, creating "a potent cocktail of leather and lace and bare skin".

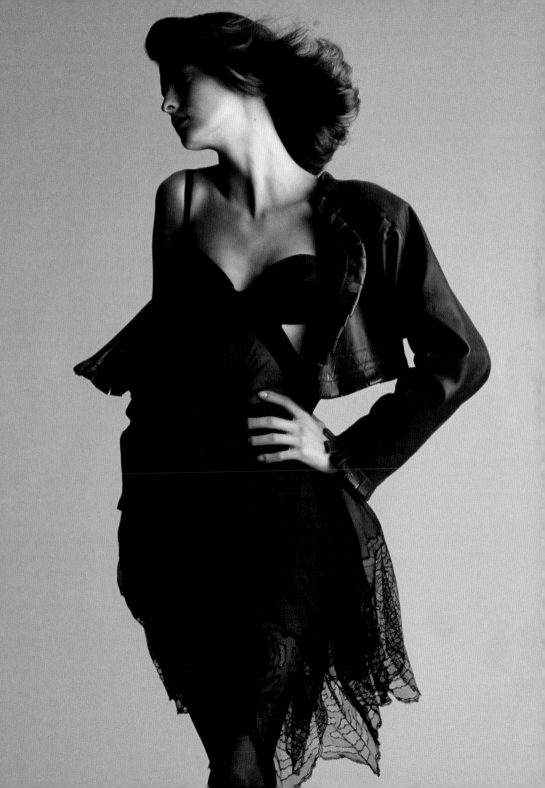

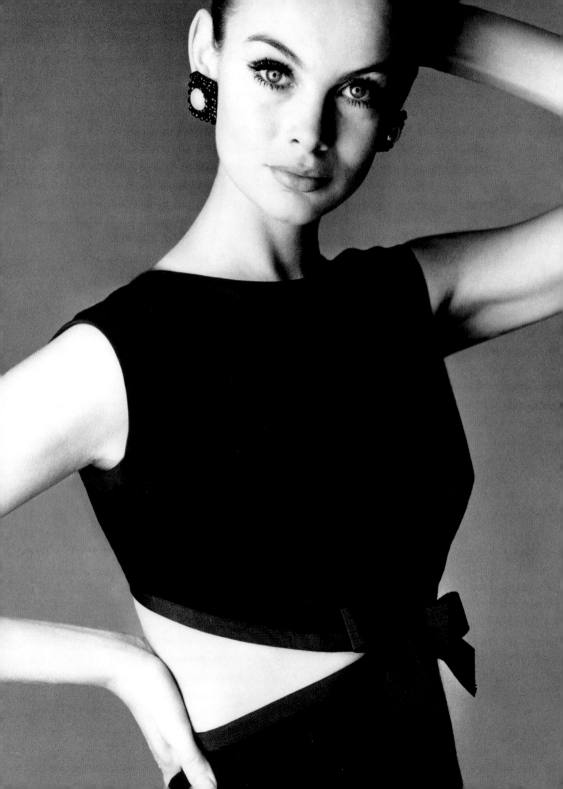

sleek simplicity

← In the November 1965 issue, a young, immaculately beautiful Jean Shrimpton stares into the lens of her photographer boyfriend David Bailey for "Vogue's Eye View". The headline announces "Cutting New Patterns; black and white, black and you." With one hand behind her head, the other gently holding her hip, the model of the moment is innocent yet knowing, timeless yet breathtakingly modern. Much of this effect is achieved by the dress itself: a short, sharp wool crepe LBD by Nettie Vogues, cut to a fine point in front, bare at the sides and across the back. It is the delicate exposure of bare skin that sets the dress – and, by extension, the photograph – apart from those that might have come before. So simple, yet so effective, it shows the LBD at its sleek, versatile best.

Looking back from our modern, permissible age, it is hard to imagine the revolutionary impact that Coco Chanel's Little Black Dress had on fashion and society. By creating a garment that was elegant but wearable, neutral in colour, long-lasting and versatile, she was presenting to those women who wore it a freedom that they had never previously known.

In the 90 years since its invention, the LBD has forgotten its revolutionary past and become a wardrobe staple. But then, as now, its practical and aesthetic power holds strong, and as a paragon of sleek simplicity, it is very hard to beat. For all its incarnations, its nips, tucks, embellishments and alterations, the LBD has arguably always worked best in its simplest state. The sketch of Chanel's original design was fashion in its purest possible form: a calf-length black sheath – nothing more.

From the very beginning, something about the versatile simplicity of the Little Black Dress chimed with every fashionable woman's needs. In the second half of the Twenties, variations on the basic theme appeared several times in *Vogue* (and even on Harriet Meserole's Art Deco cover of *Vogue* from March 1927, see page 10). "No colour smarter than black for the evening," announces a feature in the next issue, in which a black chiffon Chanel creation is shown alongside a more embellished georgette Lucien Lelong design in a Lambarri illustration (see page 21). "Black is again the outstanding shade for evening," proclaims the accompanying text. "It may be relieved with crystal beads and silver as Lucien Lelong shows it… it may be transparent and

unadorned as Chanel likes to use it... Each new version of it only serves to emphasize its extreme chic and becomingness. Other colours appear – warm our hearts, match our eyes – and disappear. Black remains – even when we are told black is démodé – always becoming, always distinguished."

For all the simplicity of the dresses being featured, there was a wonderful floridity to the text promoting them. In one September 1935 feature entitled "Black Beginnings", six reasons are given for the fashionable woman to choose black for autumn, one of which stands out particularly: "Because a black dress or suit is perfect for roaming around town in the morning, for shopping and lunching and, a little later, when the wind begins to bang the doors, you'll wear it with a fur neck-piece or cape."

As the years marched on, so, too, did the LBD, through a second world war and out the other side. For the world's greatest photographers – Cecil Beaton, Horst P Horst, Lee Miller, Henry Clarke – the LBD designs of some of the world's greatest fashion designers, including Coco Chanel, Christian Dior and Hubert de Givenchy, provided an irresistibly elegant, structured subject matter. Indeed, some of the very earliest contributions to the magazine in the late Fifties from Helmut Newton and Tony Armstrong Jones were of models wearing Little Black Dresses.

In 1960 an exciting up-and-coming fashion photographer named David Bailey met a young model called Jean Shrimpton while they were both working in the studios of *Vogue*. Over the next four or five years, their working partnership would revolutionize fashion photography. In one of their very first collaborations, as featured in the February 1962 issue of the magazine, Shrimpton stands with her back to the camera, in an open-backed LBD with crossover spaghetti straps, the only accessory a diamond bracelet (see page 42). The photograph is both classic and risqué, timeless and modern, and the dress its simple star. Three years later, in the November 1965 issue, Bailey, Shrimpton and the LBD are in collaboration again, this time to bolder, more modern effect (see page 14). But the classic impact of the dress remains the same. The formula seems very simple – a beautiful girl in a well-cut black dress, exquisitely lit and staring boldly into the lens – but the impact – as in the case of the October 1965 image by Norman Eales (see page 41) – is beyond words.

For the next three decades, until the turn of the century, the LBD would change its identity with the times, but there would

always be, in the middle of a sea of fluctuations, a place for the LBD in its simplest form. This is particularly evident in images from the Nineties, when fashion photography was once more pared back to its most impactful formula of photographer, model and dress. Take, for example, a May 1993 Corinne Day photograph of a barefoot, barely made-up Linda Evangelista in a plain black silk jersey halter dress (see page 37). No embellishment, no whistles and bells – just pure, powerful simplicity.

Time and time again, *Vogue* has come back to this fail-safe formula. As recently as 2013, Alasdair McLellan's pared-back studio photograph of Kate Upton in a high-necked Lanvin LBD, accessorized with just a pair of Manolo Blahnik shoes, has the same uncomplicated impact (see page 39). Two years later, an image of Sienna Miller from Mario Testino's October 2015 cover shoot (see page 43) has the classic elegance of a photograph that could have feasibly been taken by David Bailey half a century earlier. The same could be said of Karim Sadli's February 2017 image of a red-lipped girl against a backdrop of russet autumn leaves (see page 45). And the common thread? The timeless, quiet Little Black Dress.

Despite, and perhaps because of, its simplicity, the LBD can also be a key player in more complicated, modern photography: the weight that tethers creative balloons to the ground. Thus, it provides a perfect stillness at the heart of both Nick Knight's September 2005 photograph of a tangle of modern dancers (see pages 26–7) and Alasdair McLellan's September 2016 fashion shoot amid a troupe of stunt riders on dirt bikes (see pages 130–1).

At a time when the world is changing faster than we can keep pace with it, fashion faces an exciting, albeit uncertain, future. Predictions are hard to make, certitudes slip from our grasp, but one thing remains sure: in its cleanest, most uncomplicated form, there will always be a place for the Little Black Dress.

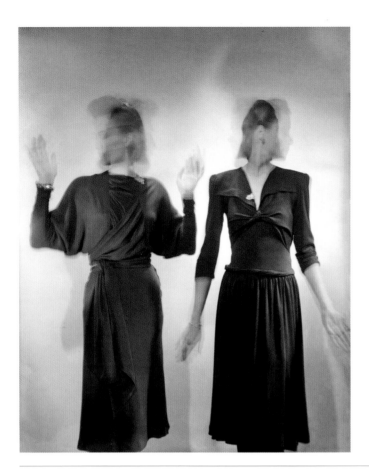

↑ A Cecil Beaton image (December 1941), with the heading "Motion Pictures", shows two simple, structured pre-war designs to refreshingly modern effect from behind a silhouetted screen. The original captions are as beautiful as the designs themselves and deserve to be quoted. "Two dresses: 1) distinguished line focusses on waist-deep dolman sleeves, on the crossover drapery which flows from the bodice into a sash-end, twisting round the waist, cascading down the hem of this afternoon dress in wine rayon marocain by Hartnell at Jacqmar and 2) lowered waistline slightly but decisively by gathering a full skirt on to a long bodice, and setting a twisted girdle low on the hipbone... by Stiebel at Jacqmar."

→ There is a powerful simplicity to this Frances McLaughlin-Gill image from September 1952, in which the Little Black Dress – designed by none other than Christian Dior – does what it does best: sculpts and flatters the wearer, while also announcing her feminine power. "Second skin dress," proclaims the caption.

"Fine black wool, shaped and moulded with a totally deceptive simplicity – to assume the shape of the woman inside it." This is Dior's version of a much-practised theme: a double line of buttons, a plain leather belt and a white bow on a high close collar, yet, in true Dior style, he makes it simply and powerfully his own. Coco Chanel was so horrified by the new male designers, such as Dior, bursting onto the fashion scene, with their so-called "illogical designs" that she returned to work in 1954, after 15 years of retirement, at the age of 71.

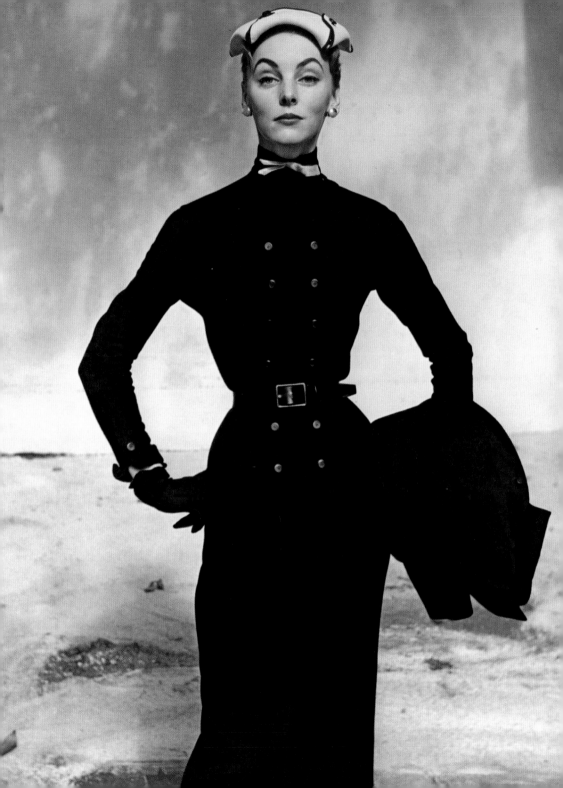

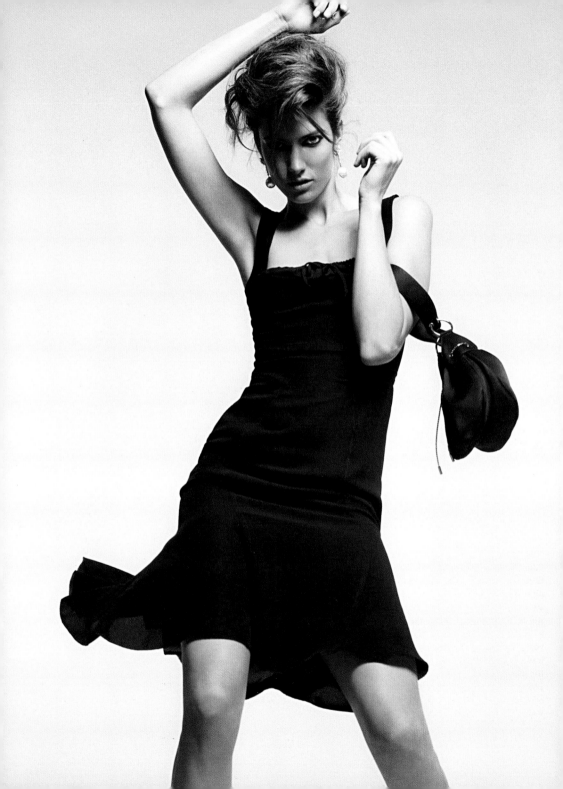

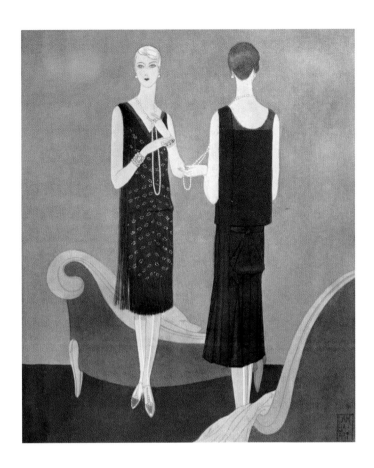

← Some of the most memorable LBDs have been created by the house of Versace, not least Elizabeth Hurley's famous safety-pinned creation, which put her on all the front pages after she stole the show at the *Four Weddings and a Funeral* premiere in 1994. Eighteen years later, for the September 2002 issue, Greg Kadel photographed the perfect black cotton Versace LBD in all its standout glory: a classic shape, given a playful kick with the sleekest bodice and the girliest skirt. Dresses like these need no fanfare or even accessorizing, just a confident wearer with plenty of spirit.

↑ "No Colour is Smarter than Black for Evening," said the late March 1927 edition of *Vogue*, which featured a Lambarri illustration of two models from Harvey Nichols showing off the latest fashions from Paris. The first is a Lucien Lelong dress in black georgette, embroidered with silver and crystal beads, with a black silk fringe to the hem; the second, a chiffon dress from Chanel, with a circular skirt stitched into a triangular pattern below the hipline. "The bolero at the back becomes a blouse in front," adds the caption accompanying the text. The final sentence reads: "Black remains – even when we are told black is démodé – always becoming, always distinguished." This remains as true today as it was 90 years ago.

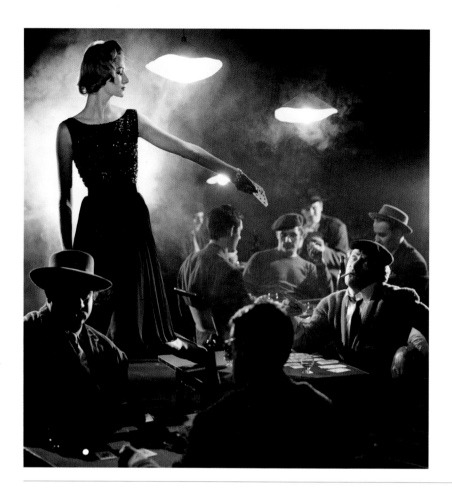

↑ "The short décolleté dinner dress," is here photographed by Tony Armstrong Jones for the October 1958 issue. Then just 28 years old, Armstrong Jones was embarking on his career as a photographer. In this image – one of his first for *Vogue* – he tells the story of "Evenings with Irma", in which the model is photographed in the smoky haze of a gambling den. Armstrong Jones was himself no stranger to the allure of city nights, and he fills this reportage-style photograph with a sense of glamour and decadence,

emphasized by the particular choice of dress – a Susan Small design. "Part of the beauty of the dress," says the accompanying caption, "[is] a glitter of jet black paillettes encrusting the bodice, a deep décolleté and soft skirt of black georgette – yards of it, spreading smoothly from the waist to a flare at the hem."

→ With the introduction of elastic Lycra fabric in the Eighties, LBDs became tighter and shapelier. Here, in an Andrea Blanch photograph from November 1986, supermodel

Yasmin Le Bon shows off this new, figure-hugging simplicity to full effect against a fast-moving London background in a story entitled "City Life, the Short Choice". The skating dress, in a black quilted stretch cotton Lycra mix, with a skinny polo-neck top by Jean-Paul Gaultier, is perfectly accessorized with a leg-lengthening pair of opaque black tights and black heels. No accessories or embellishments to speak of, just pared-down, shape-flattering simplicity, used to powerful eye-catching effect.

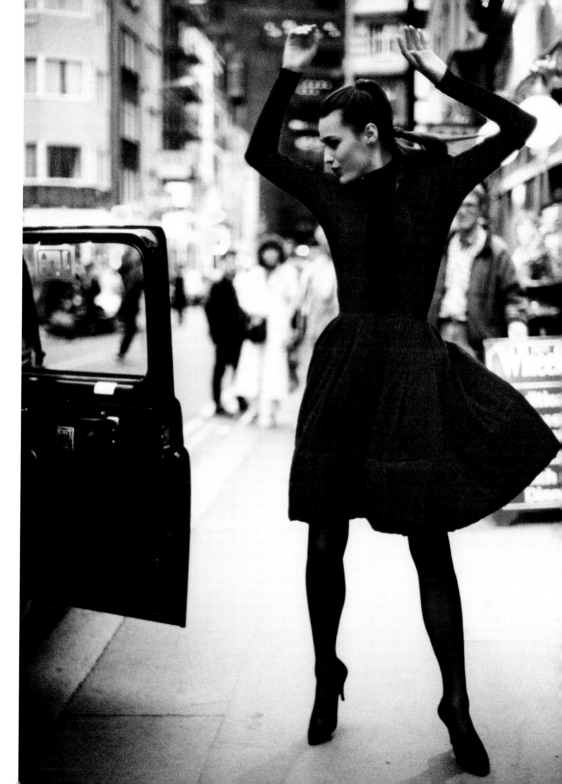

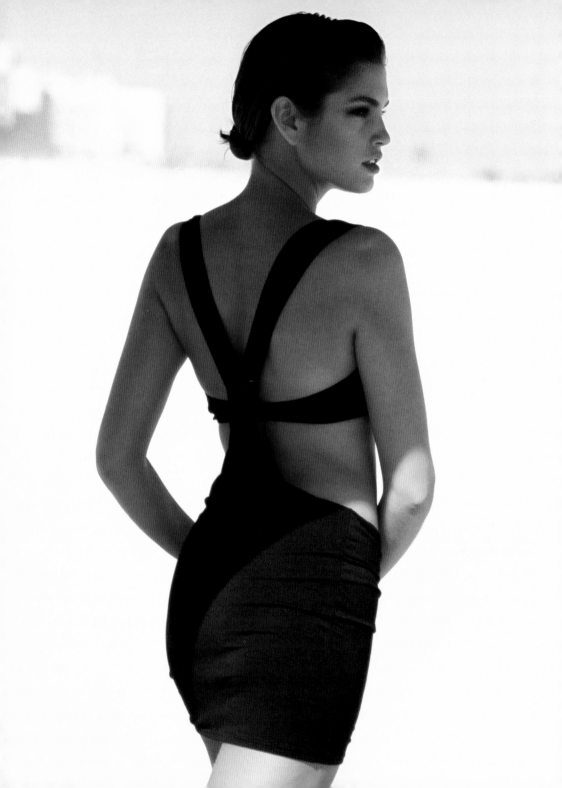

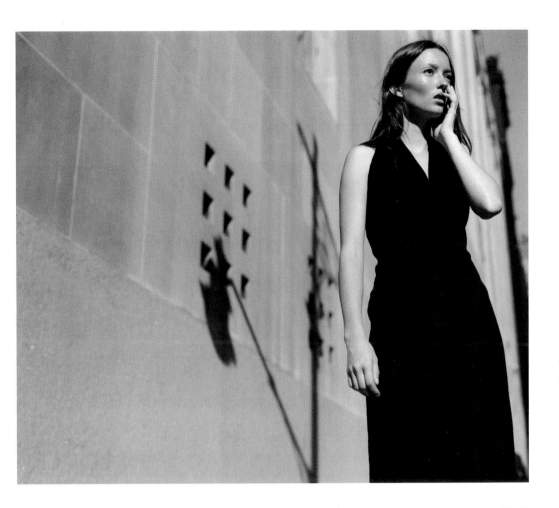

← Lycra, once again, enhances an item's "Staying Power" in this May 1987 story by Peter Lindbergh, modelled by Cindy Crawford. A black cotton and Lycra stretch bathing dress from John Galliano at Harrods, with crossed back and bare midriff, creates impact with little fanfare. This is, after all, the LBD's great power: making a statement without shouting too loudly.

↑ Every picture tells a story, and in this photograph by

Nathaniel Goldberg (October 1999), a simple, felted cashmere, halterneck dress by Michael Kors at Céline only serves to enhance the sense of urban isolation suggested by the "City Limits" story of which it forms a part. Who is this girl and where has she been? What is worrying her and where will she go? If she were wearing anything other than a simple LBD, we would be given more clues, but the very plainness of the dress only heightens the

sense of mystery. It is a blank canvas on which we, the reader, can write our own story.

→ → "Total Simplicity" is the title of this double-page spread photographed by Nick Knight (September 2005). On one side, a tangle of ballet dancers; on the other, a model in a simple Prada crepe LBD with a lace trim. Rather than detracting from each other, the two parts of the image serve to highlight the other's silent beauty.

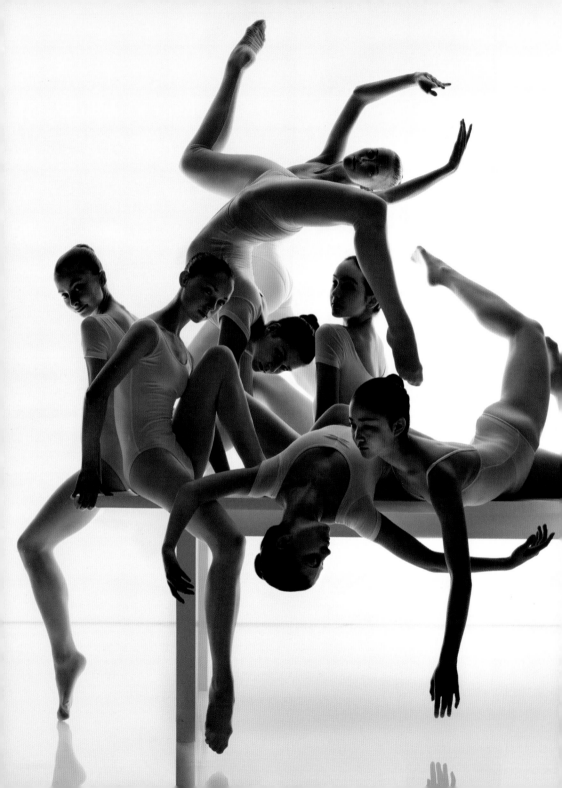

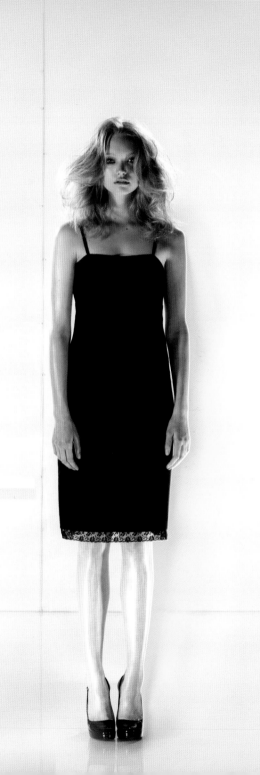

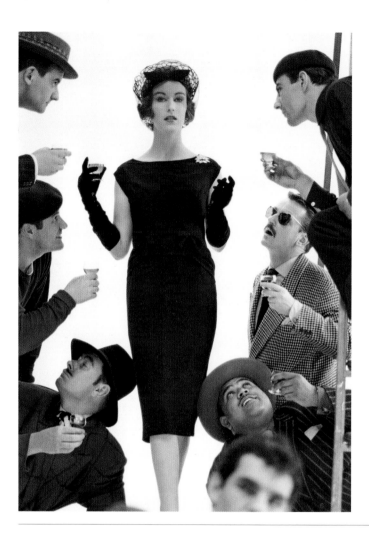

↑ This is another image from the "Evenings with Irma" shoot (see page 22), photographed by a young Tony Armstrong Jones (October 1958). It features a second LBD, a wide-necked shift cocktail dress by Rima, described in the caption as being "of slender black crêpe". Accessorized with a net velvet hat, diamanté brooch, long black satin gloves and a glass of something strong, what could possibly be more glamorous?

→ Illustrating a make up feature for the April 2011 issue of *Vogue*, three models – Daria Strokous, Lara Stone and Jac – are photographed backstage at the Calvin Klein Autumn/Winter 2011 show by James Cochrane. The sheath-like simplicity of the dresses – two with sleeves, the other without – provides the perfect backdrop for a pared-down, light-glossed beauty, set off by strappy stiletto heels. A master in the art of

flattering, unshowy tailoring, Calvin Klein has been turning out simple, beautifully made Little Black Dresses for the best part of 40 years.

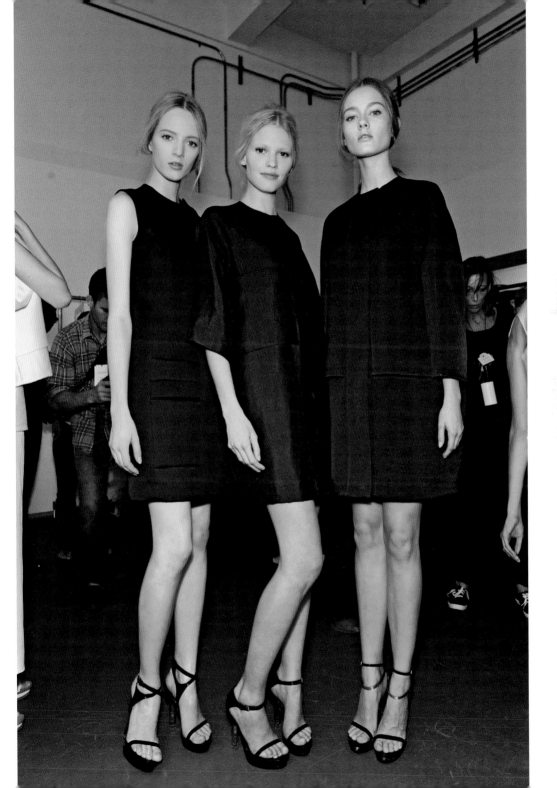

← The LBD has always been as notable for what it reveals as for what it hides. In this image by Paolo Roversi (September 1985), a floor-skimming, one-shoulder, black rib cashmere dress from Zoran at Browns makes the half-exposed wearer appear simultaneously powerful and vulnerable.

↑ A master in the art of glossy feminine power, Peruvian-born photographer Mario Testino has been responsible for documenting some of the most sensually stylish LBDs to have appeared on the pages of *Vogue* for the past 30 years. In this image from a story entitled "Couture Culture" (April 1995), the design by Valentino, with black chiffon by Taroni, traces a delicate line around the contours of the body. Set against a plain white background, with a crowning "hat" of teased black hair, the image is striking in its contoured simplicity.

↑ In "Ballet Length", photographed by John Rawlings (March 1942), a long-sleeved dress of fine black marquisette from Debenham & Freebody is accessorized with a pair of black satin ballet shoes and a diamanté brooch detail at the edge of the waistline. Although, at first glance, there is nothing particularly standout about this image, there is something about its classic elegance – an elegance that comes, first and foremost, from the dress – that simply burns into the mind.

→ For their "Love on the Left Bank" feature for the October 2015 issue of *Vogue*, photography duo Inez & Vinoodh went to Paris to showcase the work of some of the world's greatest designers against a backdrop of elegant French simplicity. Here, a pleated black silk tulle dress and knickers by Valentino glamorize an empty stairwell. "Fan the flames of timeless French style," reads the accompanying caption. "Sprays of smoky lacework make Valentino's sheer dress a fiery scene-stealer."

→ → For his November 2011 story, "The Illusionist", Mario Testino uses a perforated leather and silk-mousseline sheath dress embroidered with crystals (made to order by Atelier Versace) to pay homage to the Hollywood glamour of yesteryear. It is the dress's very blackness – starkly beautiful in a pool of white light – not to mention its sculpted simplicity, that makes the image worthy of many encores.

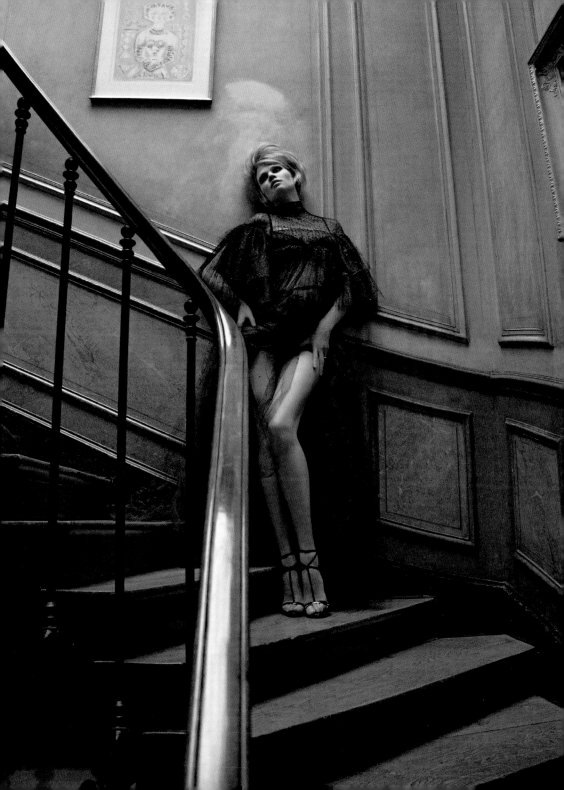

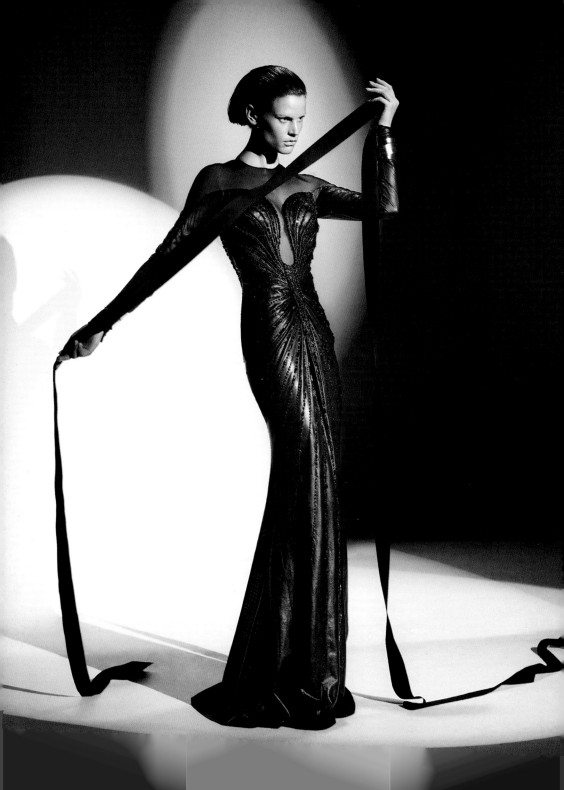

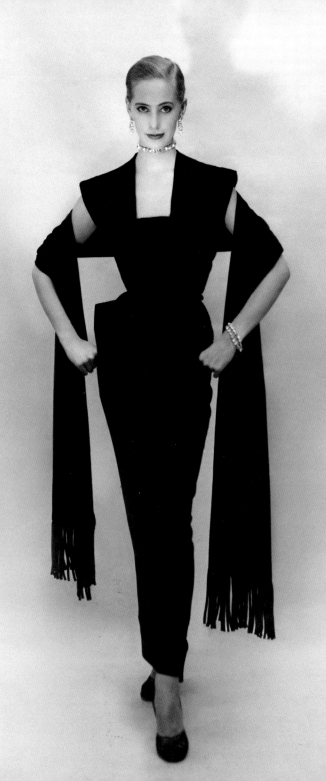

← "Probably the most perfect dress you could pick as a starting point for jewels." So reads the caption on this photograph, taken by Anthony Denney for the December 1951 issue's look at the best Christmas party dresses. The model wears a velvet dinner dress by Dorville, "exactly to the ankles, severely plain, with oblong neckline, hip pocket, wide stole." A noted tastemaker as well as fashion photographer, Denney also worked as an interior decorations editor for *Vogue* in the Fifties. In his later life, he went on to photograph interiors for *House & Garden* magazine.

↑ Perfect simplicity. Jil Sander's silk-jersey halter dress (tied at the nape and the base of the spine) and Corinne Day's clean, unshowy photography are the perfect combination in this image from May 1993, as modelled by a barely made up, barefoot Linda Evangelista. Sander's own particular breed of fashion minimalism has always made her a proponent of the pared-back LBD, the design of which she has repeatedly turned her hand to over the course of her forty-year career.

↑ For his "The Long and Short of It" story from October 2010, Paul Wetherell captures Lily Donaldson in a black silk dress with sequin detail by Mulberry. Donaldson is unadorned by flashy jewellery or bold make up, thereby allowing the dress, and her natural beauty, to speak for themselves. "Note to self," reads the caption: "jangling supersized sequins and mini lengths makes for triumphant glamour."

→ From the moment a video of her dancing at a Los Angeles Clippers basketball game was posted online in 2011, Kate Upton has been America's favourite bombshell. A charming, witty, all-American girl, Upton's curves have become the stuff of fashion legend, and a healthy antidote to the more caustic looks of some of her model counterparts. In this photograph by Alasdair McLellan for the January 2013 cover story, her

famous curves are shown off perfectly in a black neoprene dress with ruffle detail by Lanvin, thereby cementing the LBD's status as the real woman's best and most reliable fashion friend.

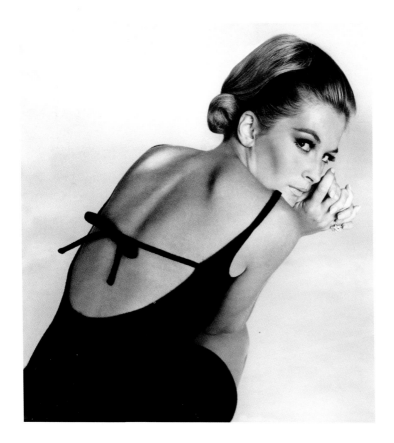

← In an article for *Costume*, published in 1975, Shane Adler Davis praised Jean Muir's extraordinary ability to design the perfect Little Black Dress. He described the Scottish-born designer as "a sculptor, moulding with her lengths of cloth". Muir's use of silk jersey was legendary, and this little black number, with a spinning bias cut, is shown in all its fluid beauty in this photograph by Arthur Elgort (March 1980).

↑ Could this be the most alluring Little Black Dress? Norman Eales's photograph (October 1965) of a slender LBD by Frank Usher stays in the mind; the Grace Kelly-esque beauty of the model, the lighting of the photograph, the simple tie at the back of the dress are almost impossible to beat.

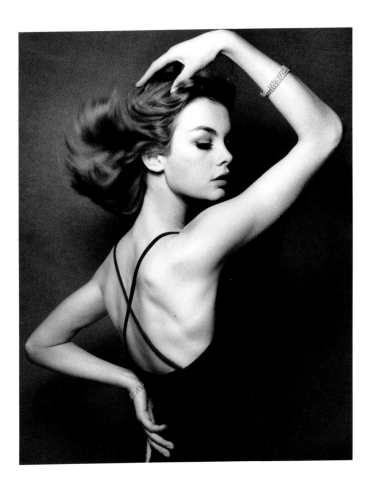

↑ Jean "The Shrimp" Shrimpton was a modelling sensation in the Sixties. For the "Young Ideas" story in the February 1962 issue of *Vogue*, photographed by David Bailey, her boyfriend at the time, Shrimpton shows off this narrow black dress with crossover rouleau straps by Frederica to statuesque perfection.

→ Few modern-day actresses can boast the same level of traditional glamour as Sienna Miller, poised here in Mario Testino's opulent cover story "Cooking Up a Storm" (October 2015). Miller wears a black silk LBD from Temperley London: plain, beautifully cut and simply stunning, with a flash of decadence in the gold silk lining.

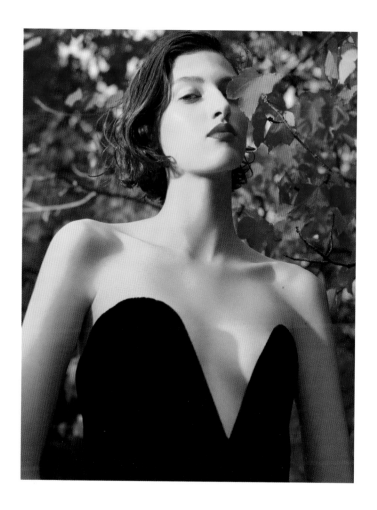

← For the same story as featured on page 36, Anthony Denney shoots another LBD in a powerfully handsome image of pure drawing-room perfection (December 1951). The dinner dress in black alpaca, with the widest possible V neckline and a crossover bodice, is by Auerbach from Rocha.

↑ For his first collection at the house of Saint Laurent, Anthony Vaccarello took on the Little Black Dress. His velvet minidress, with an extreme heart-shaped neckline, was dubbed something "to lust over" in the caption accompanying Karim Sadli's photograph (February 2017).

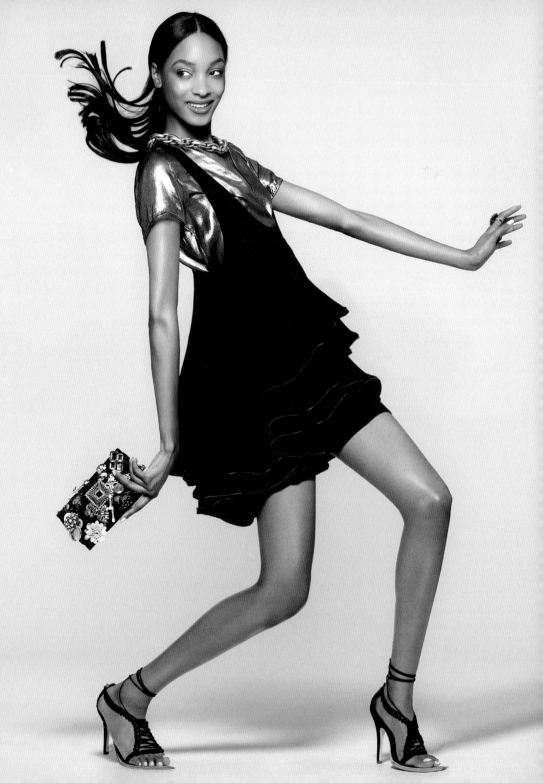

all in the
detail

If a black dress is a blank canvas, then the accessories that one chooses to adorn it with take on a painterly significance. As Marc Jacobs once pointed out, "Any opportunity to adorn oneself is human," and, of all the possible outfits to use as a starting point, the Little Black Dress is arguably the most versatile of them all.

Coco Chanel was famous for accessorizing. "Accessories," she declared, "are what makes or marks a woman." It is no coincidence that she was the inventor of the ultimate backdrop for beautiful accessorizing: the black velvet on which the jewels could glint. In the *Vogue* image from March 1927 of her black chiffon, drop-waisted evening dress (see page 21), the overall impact is accented with a pearl necklace and pearl drop earrings.

Since its invention, a rope of pearls has been the LBD's most reliable sidekick. By the Thirties, the longer rope had given way to a shorter, more choker-like version, as shown on the *Vogue* cover of April 1930 (see page 61). Well into the Fifties and Sixties, this fashion was showing no sign of letting up, as perfectly illustrated by both Norman Parkinson's image from March 1950 and Don Honeyman's from August 1960 (see pages 68–9). In the latter, the model sports another LBD accessory of note – the cigarette holder – which was also taken up, pearls and all, by Audrey Hepburn for her iconic portrayal of Holly Golightly in the 1961 film *Breakfast at Tiffany's*.

Like the LBD, pearls have shown an enduring commitment to fashion but so, too, have diamonds. From the diamond brooch worn on the shoulder of Anthony Denney's powerfully handsome

← The LBD lends itself perfectly to accessorizing. In the "More Dash Than Cash" feature photographed by Jason Kibbler (June 2009), a simple minidress with zip trim from the chain store Next is made instantly fashionable with the addition of a gold-coated silk top, resin chain necklace, strappy sandals by Preen for Topshop and a satin Wilbur & Gussie clutch bag customized with vintage brooches. "Carry your clutch as jewellery," advises the caption. "Adorn with clusters of pin badges and brooches." Proof, if needed, that the LBD is only just the beginning.

December 1951 model (see page 44) to the diamanté piping on the dress worn on Helmut Newton's October 1973 cover (see page 9) – or winking on the back of Oliviero Toscani's October 1974 cover star (see page 11) – these two enduring classics have perfectly complemented each other's timeless beauty.

As time has moved on, the jewellery paired with LBDs has developed and modernized, as have, inevitably, the dresses themselves. From the Nineties onward, stylists seemed to move away from straightforward classic looks to something bolder, brighter and more avant garde. Once again, the LBD was often placed at the centre of their vision – the perfect plain backdrop for colourful departures, whether the oversized beads worn by Lily Donaldson in Carter Smith's story from February 2005 (see page 53) or Javier Vallhonrat's piles of stacked lacquer in September 2009 (see page 78).

While jewellery might be fashion's most obvious accessory, let us not forget its less showy sidekicks: the hat, gloves and handbag. For a short period, a hat and gloves were, at least during the day, *de rigueur* for the fashionable woman. Naturally, this was reflected in the pages of *Vogue* and thus a journey through the pages of the magazine's first 40 years of life sees its models, more often than not, maintaining a ladylike stance with the help of these fail-safe accessories. In the Forties, particularly, a woman's choice of hat was as important as her choice of dress, and the combination could be used to powerful visual effect, as exemplified by Norman Parkinson's photograph from November 1944 (see page 79). By the Sixties, fashion's revolution had all but swept away the wearing of hats, replacing them with more frivolous accessories, such as the bow in the hair of David Bailey's December 1964 model (see page 54) or the flower behind the ear of Anjelica Huston in Bailey's famous January 1974 location shoot (see page 81), in which the actress modelled alongside the then fledgling shoe designer Manolo Blahnik.

Since the Nineties, the LBD has provided the perfect backdrop for hats and headgear of many different styles, from Peter Lindbergh's Latino simplicity, as modelled by Helena Christensen in September 1990 (see page 65), to Mario Testino's outré dressing-up-box headdress, as worn by Kate Moss in October 2008 (see pages 76–77). Most amazingly, rather then being rendered invisible by accompanying accessories, the LBD more often than not manages to achieve the opposite, showing itself

to be bolder and more brilliant, more modern and exciting when worn with something unexpected. Nowhere is this better shown than in Patrick Demarchelier's photograph from August 2009 (see page 57), in which a seemingly unremarkable puff-sleeved little black minidress is made magical by the addition of a pair of oversized taffeta ears.

While handbags never make anything they are worn with seem magical, they can certainly – in the right context – raise the game. While once, like hats and gloves, they might have been aesthetically undervalued, handbags have since become fashionable consumer items in their own right. Thus, the standout piece in Regan Cameron's April 2006 shoot (see page 60) is not the Chloé LBD but the mustard yellow Hogan handbag that it is paired with, while the most frivolous, exciting thing about Jason Kibbler's vibrant June 2009 shoot (see page 46) is not so much the gold-coated T-shirt worn under the Next swing dress as the colourful, customized Wilbur & Gussie clutch bag, which makes the picture pop.

One particular photograph, taken by Angelo Pennetta for the May 2016 issue (see page 58), stands out from all the rest, and is a visual reminder of how far, in its role as a blank canvas, the LBD has come. Smiling into the camera, the model wears a black Jacquemus minidress, with an asymmetric neckline, fastened by a disc-embellished necktie. The colour of her lipstick is picked out in the red of the disc and the trailing fabric – is it belt or embellishment? – that hangs from her left hip. On her arms she appears to be wearing oversized white "gloves" – or are they shirtsleeves, or perhaps a part of the dress? – that echo the white of her box-fresh pumps. Here, in one single image, dress and accessories seem to have merged into one, with each enhancing the impact made by the other and pointing to a future where distinctions blend and fashion morphs into something that we are certain we have never seen before.

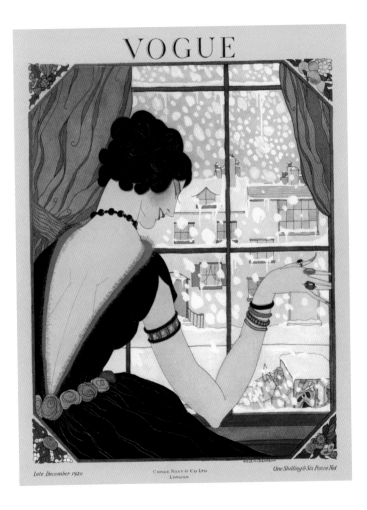

↑ As early as 1920 – even before the LBD began its own fashionable life – a black garment was being shown as the perfect starting point for impactful accessorizing. In this late December 1920 cover, illustrated by Helen Dryden – a prolific fashion illustrator who also turned her hand to costume design and, later, industrial design – a low-backed, fur-lined black evening dress is the starting point for a number of bold stylistic choices, such as a silk rose waistband and beaded armlet. Note also the wristful of bracelets and handful of rings, including one on the model's thumb. When a dress isn't crying out for attention, there is seemingly no end to all the talking that one's jewellery can do.

→ For stylist-photographer Venetia Scott's "Halcyon Days" feature (November 2014), it is the studded bib on the Emporio Armani black velvet cocktail dress that adds a certain glam-rock spin. A master in the craft of the Little Black Dress, Italian designer Giorgio Armani, who once famously remarked that "a little bad taste is like a nice splash of paprika", has always had an instinct for injecting a dash of something eye-catching – most of it usually immensely tasteful – into his beautifully made designs.

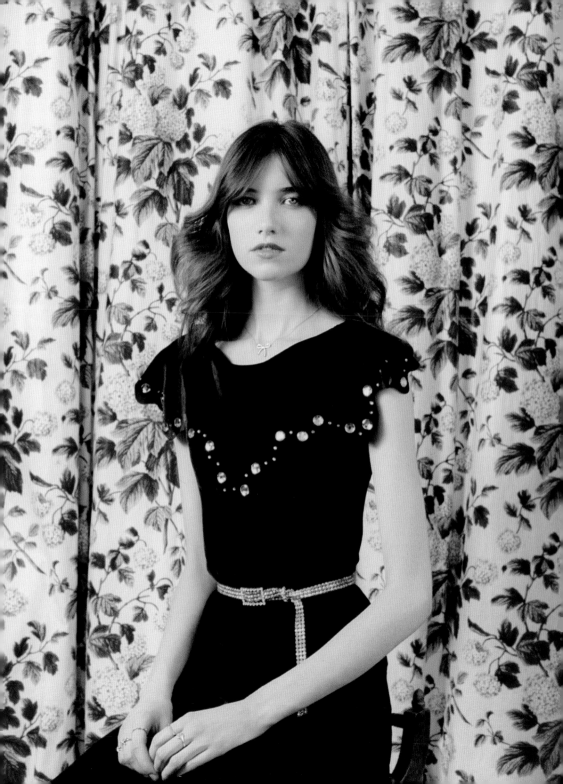

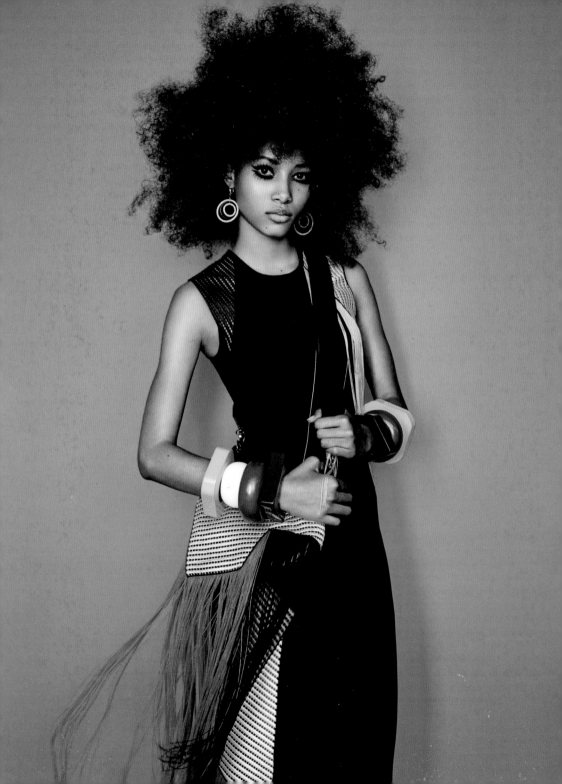

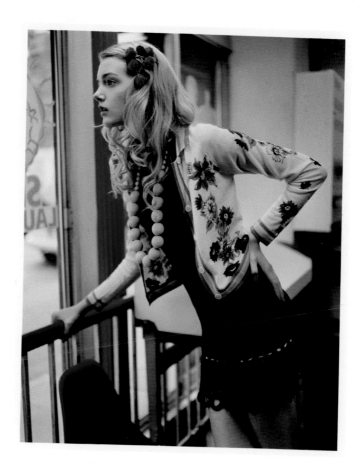

← Wrist work. In Patrick Demarchelier's February 2016 "Colour by Numbers" story, a sleeveless Christopher Kane dress with fringing is paired with a leather bag from the same designer, oversized vintage earrings and stacks of colourful geometric bangles to powerful effect. The yellow bangles from Dsquared2, the blue from Alexis Bittar and dark green bangles from Marni work perfectly to punctuate this bold and contemporary look. Styled by *Vogue*'s fashion director Lucinda Chambers – a longtime fan of large, statement jewellery – these big, bold accessories bring an otherwise simple dress to vibrant life.

↑ What you layer over a simple Little Black Dress can turn it into something truly memorable. In Carter Smith's "Sunday Girl" story (February 2005), featuring Lily Donaldson, a black wool-mix Prada minidress with crochet trim is rendered instantly girly and flirty by its pairing with a Paul Smith floral cardigan and the addition of an oversized string of chunky yellow beads and a colourful pompom hair clip.

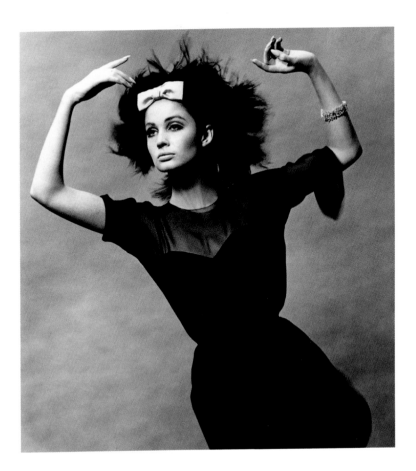

↑ More than 50 years before
Corinne Day used unexpected
headgear to accessorize her
photograph of a simple LBD (see
opposite), David Bailey was making
his own statement in a December
1964 story charting "Party Looks
for Modern Day Heroines". In this
striking black-and-white image,
a classic black chiffon corseted
dress by Cavanagh Ready-to-Wear
is made playful with the simple
addition of a girlish hair bow.

→ In one of her last photographs for
Vogue before her untimely death
from a brain tumour in 2010, Corinne
Day displays a characteristically
original take on accessorizing in
her "New Look" story (September
2007). Taking as its base a silk dress
with marabou feather trim by Boss
Black, the image creates its own
new look with the addition of a
hat, made from intricately folded
newspaper pages, perched jauntily
on the model's head.

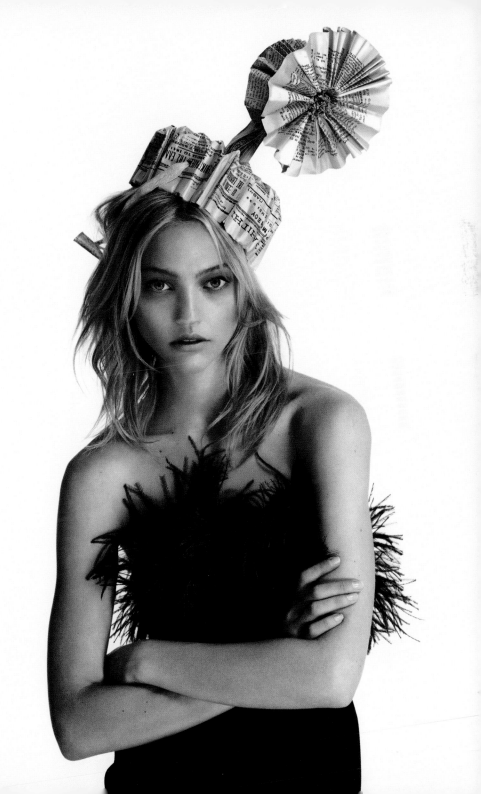

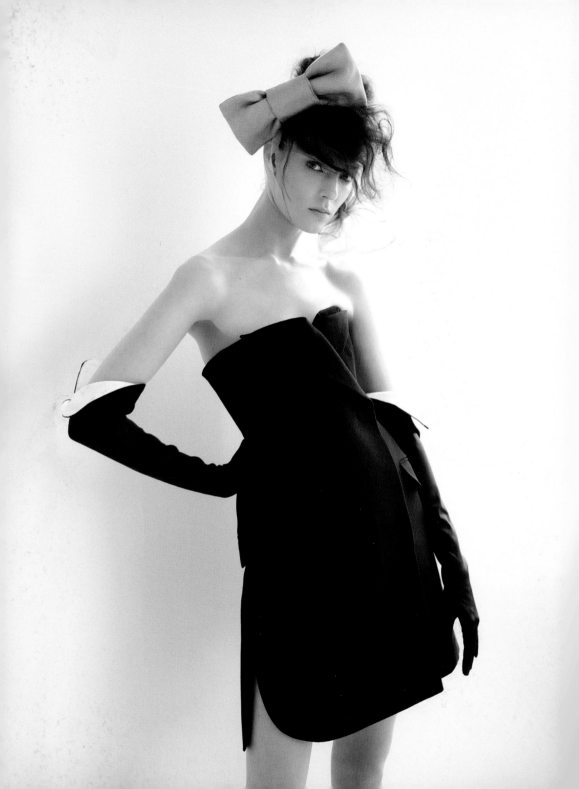

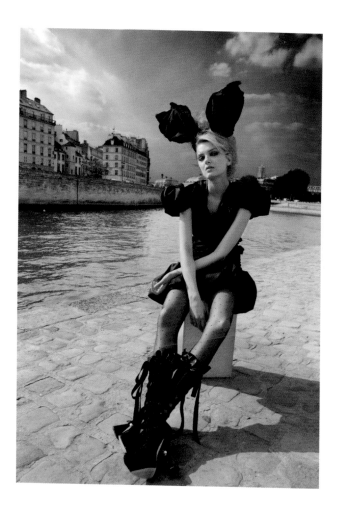

← "Dior gets a twenty-first-century new look, courtesy of Raf Simons," reads the caption for this February 2013 image by Patrick Demarchelier. An elegant strapless silk tuxedo dress and long black satin gloves are made fresh and modern by *Vogue* fashion director Lucinda Chambers with her playful addition of an oversized grey bow on the model's head.

↑ "I don't stop at my past. I like new work. I like what I'm doing tomorrow." So said legendary fashion photographer Patrick Demarchelier, who took this playful shot on the banks of the River Seine in Paris when he was 66 years old. The puffed hem, shoulders and ears infuse the Marc Jacobs cocktail dress for Louis Vuitton with a contagious *joie de vivre*. "To be worn until dawn," announces the caption

accompanying the photograph (August 2009), in which the Little Black Dress is just the starting point of the story.

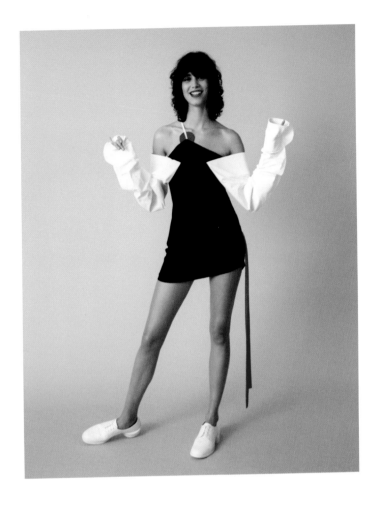

↑ It is not the black cotton
minidress by Jacquemus that
makes this photograph for the
May 2016 "Dépêche Mode" story
by Angelo Pennetta interesting;
it is its pairing with the oversized
white shirtsleeves and plain
white plimsolls. Visually, this
is the perfect example of what
fashion and the magazine that is
its bible do best: taking a classic
starting point and constantly
modernizing its impact.

→ For his May 1990 "Optics at
Ascot" story, Michel Comte
takes a sharply shaped long-
sleeved shift minidress and pairs
it with little white gloves and a
white David Shilling feather nest
hat for a modern take on a classic
British sporting institution. The
two-tone white leather lace
courts with black leather heel and
toe cap by Manolo Blahnik also
add an extra dimension – classic
modernity with a twist.

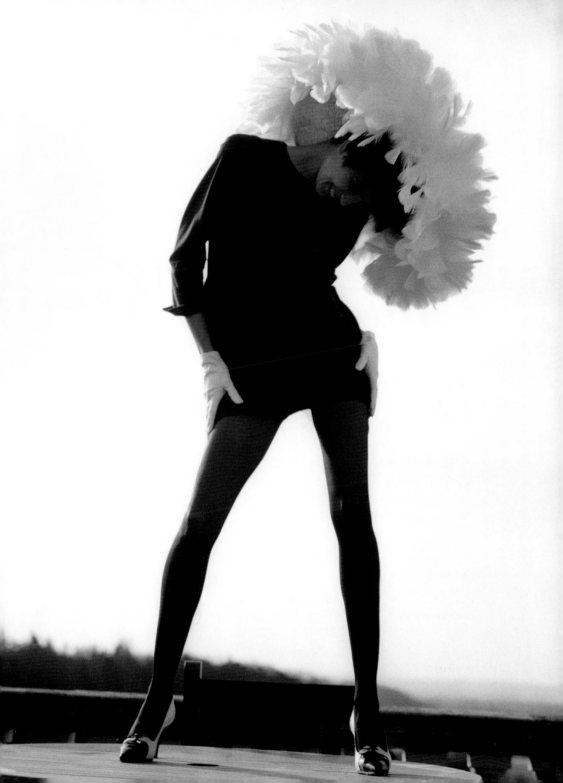

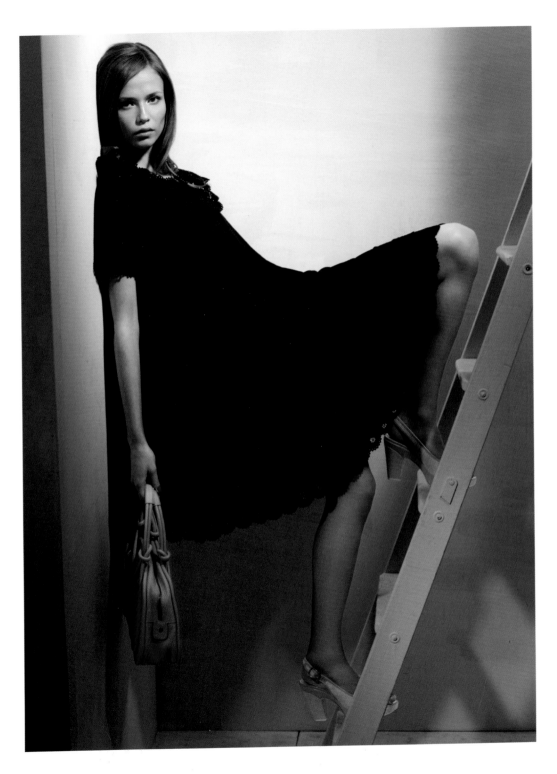

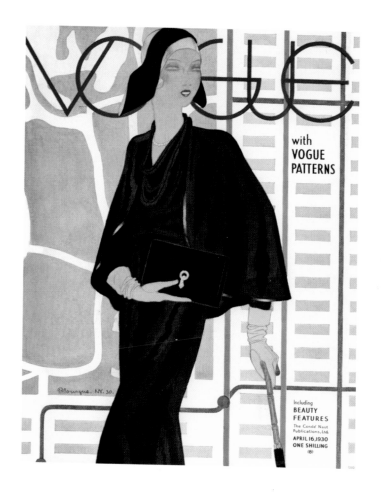

with
**VOGUE
PATTERNS**

Including
**BEAUTY
FEATURES**
The Condé Nast
Publications, Ltd.
**APRIL 16, 1930
ONE SHILLING**
(B)

← Sophisticated black with a lace trim and plenty of swing, this Chloé silk dress with embroidery is the standout star of Regan Cameron's "Get in Shape" story (April 2006). The dress might not, perhaps, have such a significant impact were it not for its pairing with mustard yellow platform slingback mules and a matching Hogan handbag.

↑ Pierre Mourgue illustrated this striking April 1930 cover of *Vogue* – the accessorizing of the black caped dress with leather gloves, a diamanté clasp clutch bag, a string of pearls and an elegant bamboo walking cane is particularly noteworthy.

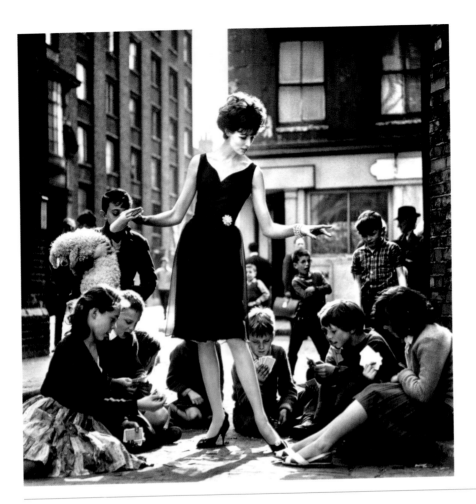

↑ Those in the know argue that it was the French photographer Eugene Vernier who opened the innovative, creative door that the new, streetwise breed of photographers – David Bailey, Terence Donovan et al – walked through in the Swinging Sixties. Vernier joined the staff at *Vogue* in the late Fifties on strong recommendation from Alexander Liberman, the legendary art director of American *Vogue*. During World War II, Vernier had worked for Pathé News and the Free French Forces and he therefore brought a journalistic eye to his fashion work. In this photograph from the July 1961 issue of *Vogue*, Vernier places his model – dressed in a black chiffon shift dress by Nettie Vogues, cinched closely at the bodice and wafting over a straight taffeta skirt – in the middle of a children's street game of cards. Looking closely at the picture, one wonders if the thing that truly draws the eye away from the card game to the model in its midst is the diamanté brooch at her waist.

→ "A firm favourite, a standby – call it what you like, there is no substitute for the little black dress, supremely right for almost all occasions, the perfect foil for you and your accessories all day long." So says the caption for Cecil Beaton's photograph (November 1953) of a Rembrandt dress, in "supple rayon jersey, the bodice draped, the skirt slender", tastefully offset with ropes of pearls, long white gloves and a dark lipstick.

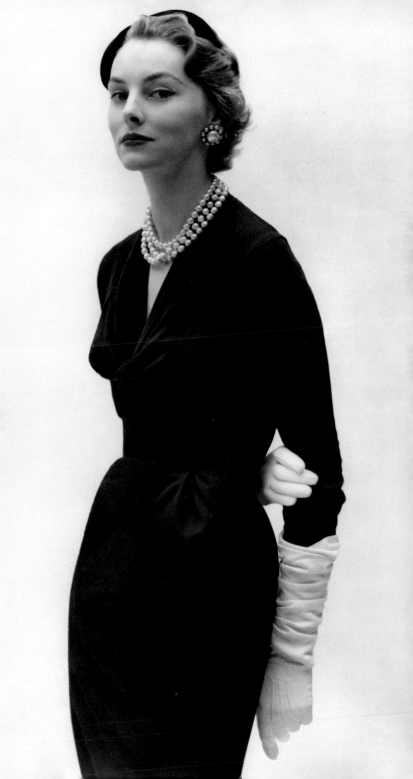

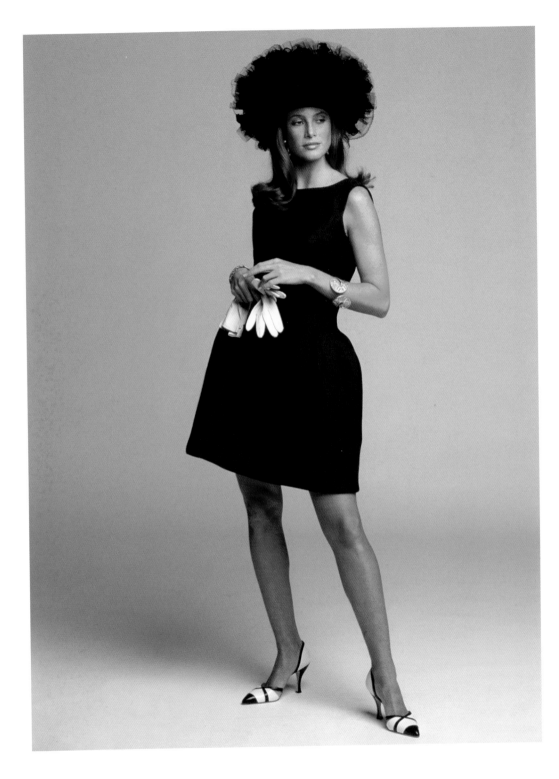

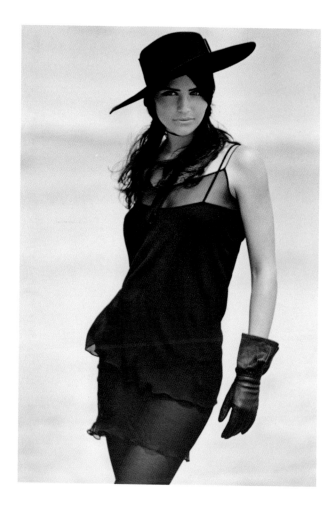

← In his "VIP Dressing" feature (April 1992), Terence Donovan takes as his centrepiece a black silk gazar dress by Anouska Hempel. The magic, however, is in the detailing: a net pompom hat by Graham Smith, white leather gloves from Gemini fashion accessories, monochrome kitten heels by Manolo Blahnik, and wood-and-gold-leaf cuffs from Arabesk.

↑ In the Nineties, a group of glossy Amazonian goddesses burst onto the modelling scene and became known, henceforth, as "The Supermodels". When worn by them and photographed by glamour-hungry photographers, the Little Black Dress exerted an even greater power. In this Peter Lindbergh image (September 1990), the impact of Helena Christensen is undeniable in a georgette and chiffon creation by John Galliano.

However, it is the accessories paired with it – black leather gloves and a Spanish bolero hat – that make the most memorable mark.

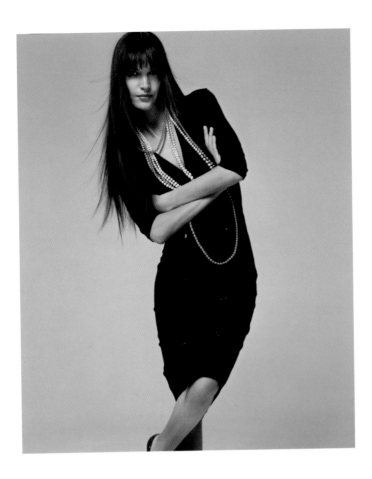

↑ "A woman needs ropes and ropes of pearls," declared Coco Chanel, the originator of the Little Black Dress. "Pearl is always right." It can be no coincidence that Chanel's most famous fashion creation is always shown in its best light with a string of these precious jewels from the deep, as perfectly illustrated in this July 2005 photograph by Regan Cameron, featuring a double-breasted black tux dress by Stella McCartney.

→ For the millennium issue of *Vogue*, published in December 1999, *Vogue*'s editor-in-chief Alexandra Shulman asked Nick Knight to photograph the most famous models of the 20th century. Victoire Doutreleau became Christian Dior's model in the Fifties when Yves Saint Laurent was a young designer at the venerable house. She then went on to become his muse. In this photograph, Doutreleau,

by this time in her sixties, is shown shoeless and wearing her own clothes at select Chanel boutiques. But, once again, it is the accessories – a pearl necklace, brooch, bracelet and earrings – that take centre stage.

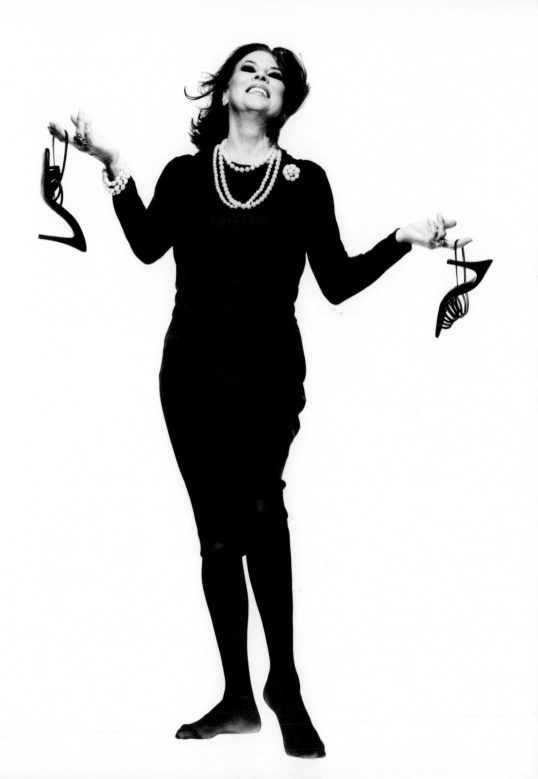

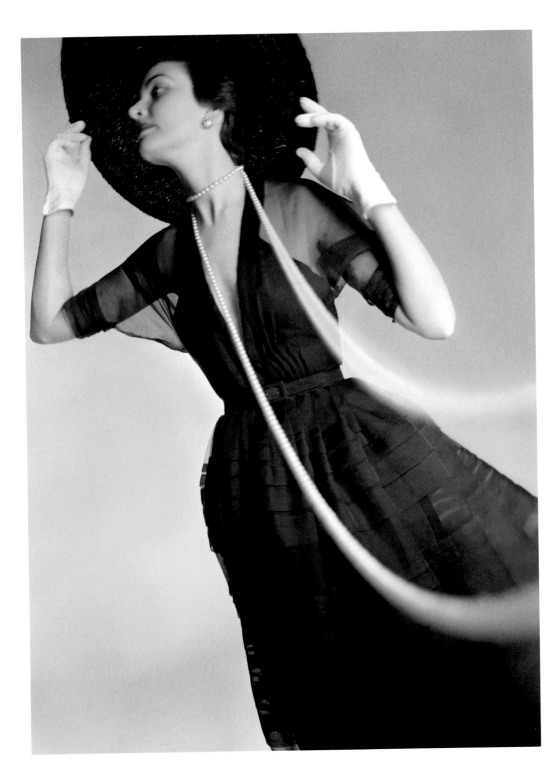

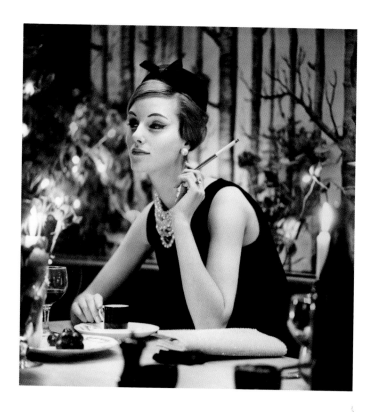

← For his March 1950 feature entitled "The London Way", photographer Norman Parkinson makes this black organza dress by Worth come alive by capturing it – and the knee-length string of pearls it is paired with – in vibrant, swinging motion. With a wide skirt, separated by graduated bands of tucking, a deep, narrow neckline and raglan sleeves, this dress is LBD perfection. For all its fresh modernity, however, the photograph harks back to a more conventional past by showing the model in neat white gloves and a wide-brimmed hat.

↑ In this Don Honeyman image from August 1960, a Frederica black wool dress – "unsleeved, uncollared, uncomplicated; a dress to count on for city days and non black-tie evenings" – is shown off to full effect by the addition of a collar of pearls, an elegant hat and, best and most glamorous of all, a cigarette holder. Within a year, the film *Breakfast at Tiffany's* would have immortalized this look, as worn by Audrey Hepburn in a strikingly similar outfit designed by a young Hubert de Givenchy.

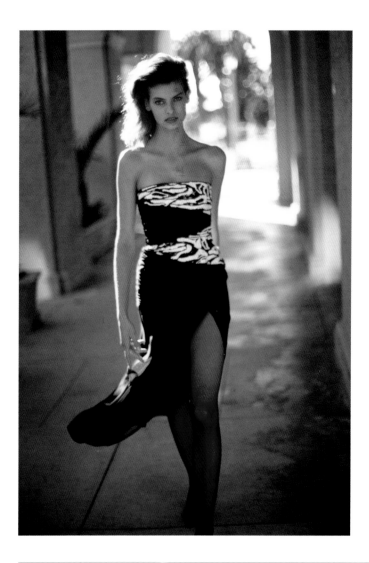

↑ "The most summery dance, Goodwood and the hottest Fourth of June, the sharp delight of black and white, bareness night and day." So reads the caption for this photograph from Arthur Elgort's feature "London Seasoning" (May 1987), in which a strapless sequin and silk chiffon sarong dress by Jean-Louis Scherrer is beautifully accessorized with its own embroidered detailing at the bust and waist.

→ In this photograph by Miles Aldridge (November 1995), Claudia Schiffer wears a Christian Lacroix sleeveless black lace and satin cocktail dress with lace underskirt, which is brought alive by its own delicate detailing. "Black lace is the most important texture for night," reads the caption. "With black satin it's sexy and modern."

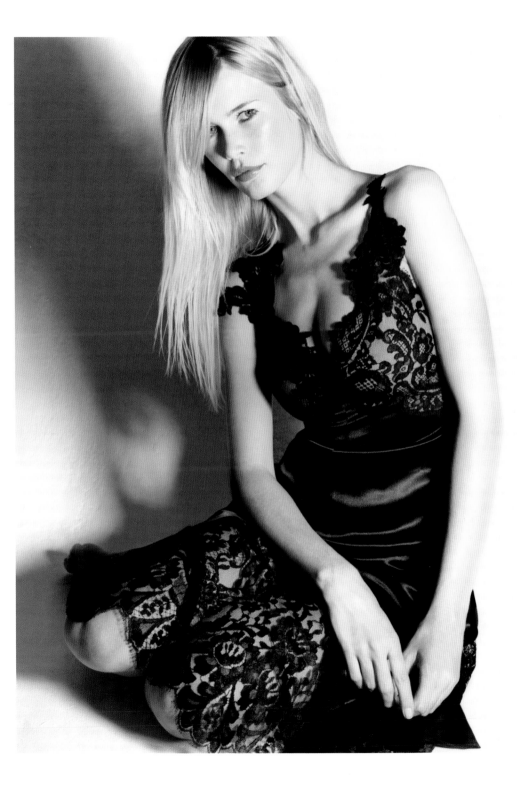

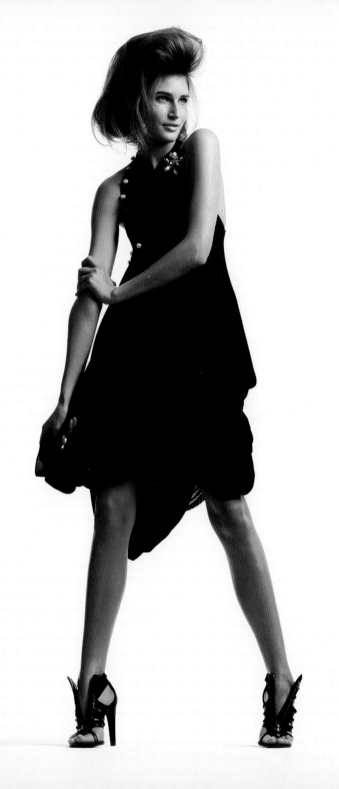

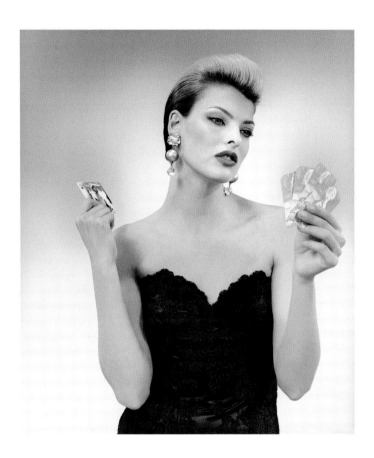

← "The Little Black Dress parachutes into 2005 with a dramatic floaty hemline". So declares the caption on this photograph, captured by Thomas Schenk for the March 2005 issue. A backless crepe dress, by Balenciaga by Nicolas Ghesquière, is made softer, and more romantic, by the addition of a vintage pearl and gold brooch from Grays antique market. The model's back-combed quiff and unzipped stiletto sandals (also by Balenciaga by Nicolas Ghesquière) create a fresh, modern feel.

↑ In David Sims's story "Card Sharp" (January 1996), featuring the supermodel Linda Evangelista, a large pair of bold diamanté and pearl drop earrings contrast powerfully with the delicate scalloped lace bustier dress by Missie Graves and Graham Hughes. As ever, the clean lines of the LBD serve as the perfect backdrop for showcasing jewellery.

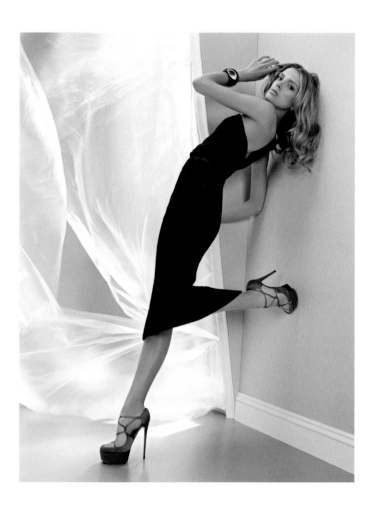

↑ Lily Donaldson shows off a silk-mix asymmetric shoulder dress by Versace to stunning effect in this photograph by Emma Summerton (August 2008), but it is the chunky bangle and the stiletto platform shoes that draw the eye the most.

→ "Christopher Kane's bandage-tight dress sculpts a classic hourglass silhouette," reads the caption to Patrick Demarchelier's photograph (July 2007) in the

"Body-con" story, featuring Lily Cole. The dress is certainly the LBD at its flattering best, but the way that its elastic tightness is broken up with ruffles on the sleeves is also of particular note.

→ → Kate Moss stars in Mario Testino's stunning October 2008 story "Hope and Glory". As ever, nobody does it better than Moss, particularly when wearing a black embroidered tulle and lace dress

by Dior. But it is the addition, by *Vogue*'s fashion director Lucinda Chambers, of a black feathered headdress with a Union Jack band and cap brim – particularly powerful when contrasted with the dilapidated beauty of the set – that elevates the photograph to the realms of the unforgettable.

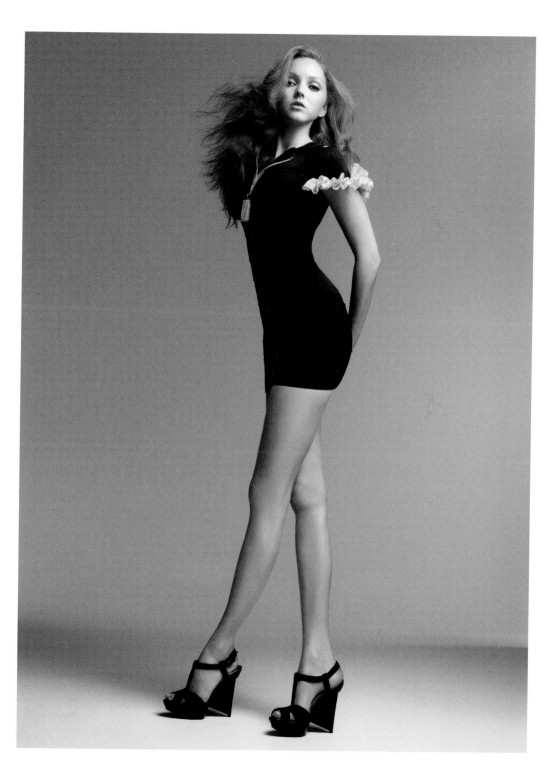

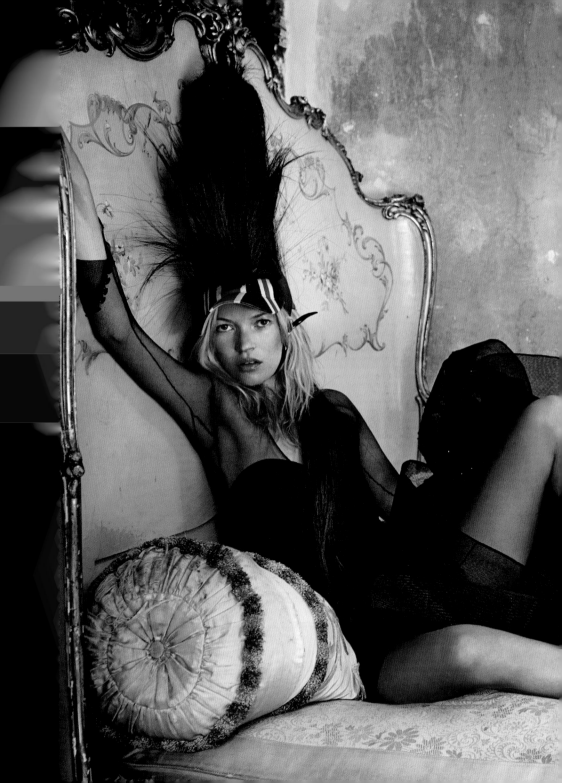

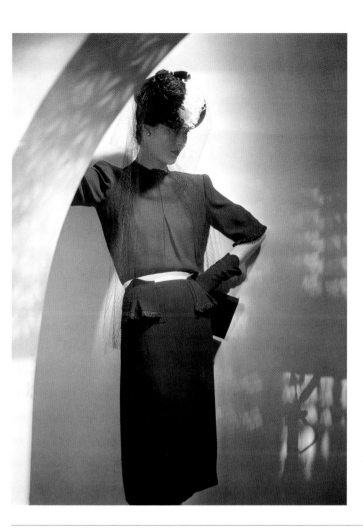

← "Complement the elegant restraint of Armani's gown with constellations of precious accessories," advises the caption for this photograph by Javier Vallhonrat (September 2009) for the "Enter the Dinner Dress" story. If proof were needed that one can never wear too many accessories with a Little Black Dress, it is surely here for all to see.

↑ Photographs by Norman Parkinson were always imbued with a cinematic drama. In this image, taken for the November 1944 issue of *Vogue*, a model hovers mysteriously in a silhouetted archway. According to the caption, she is wearing a "Molyneux black crepe dress, mustard belt, [with] unpressed inverted pleat in sleeves and bodice." Without the addition of the delicate mustard belt,

the dress would be too blocky. And without the netted hat, black gloves and clutch bag, the photograph would lose some of its filmic mystery.

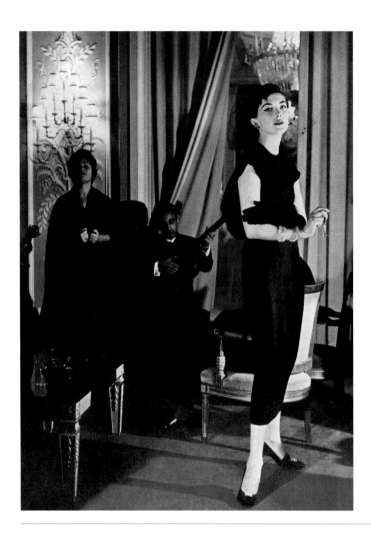

↑ The American photographer Henry Clarke was famous for his ability to combine the fantasy of fashion with the energy of photo-reportage. In this image, taken for his "Portugal" story in the February 1957 issue of *Vogue*, the model, standing elegantly aloof in front of some musicians in the Palace Hotel at Estoril, wears a new-length black cocktail dress in silk shantung by Horrockses at Woodlands.

→ Styled by model-turned-stylist Grace Coddington and photographed by David Bailey, the "French Leave" story (January 1974) became the stuff of fashion legend, not least because of its cast of models, which included the actress Anjelica Huston, the shoe designer Manolo Blahnik, the photographer Helmut Newton and Coddington herself. The shoot took place over three weeks in the summer of 1973 and made

stars out of the models and the photographer alike. Here, Huston, pictured with Blahnik, wears an ebony crepe de Chine dress with lace edges and string straps, made to order at Bellville-Sassoon, with Manolo Blahnik strappy mules on her feet. And the accessories? Beautiful orchids – nothing more.

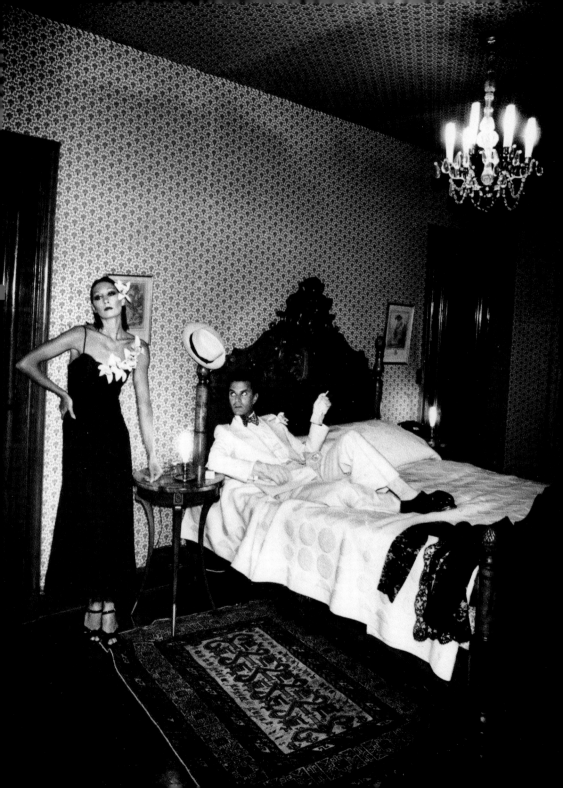

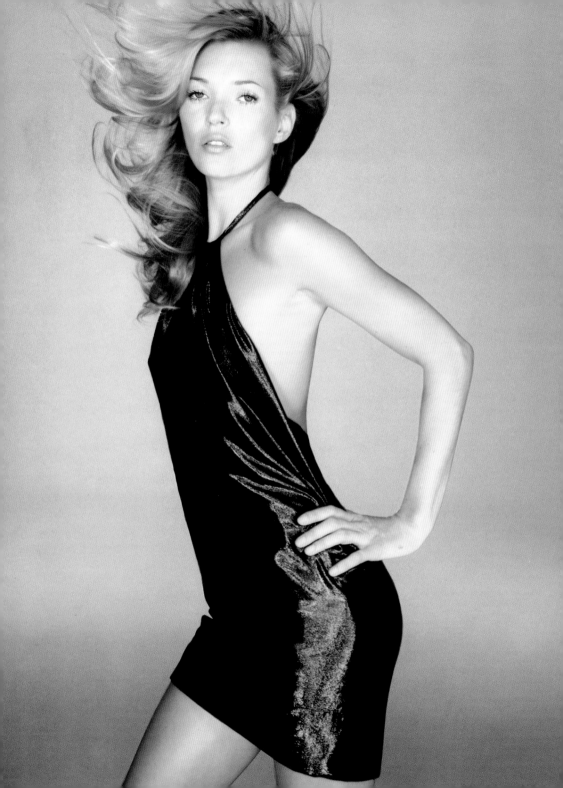

vamp it up

The real strength of the Little Black Dress lies in its versatility. Worn in the right way, it can be anything the wearer wants it to be, and more. Empowering or demure, eye-catching or elusive, sensual or sensible, it is the fashion statement to end all fashion statements.

The most enduring fashion icons of all time have harnessed the LBD's power, and since its beginning, this simplest of outfits has carried with it a hint of rebelliousness, a flirtatious sartorial call to arms for women unafraid to stand apart from the crowd.

Marilyn Monroe knew better than anyone the force of simple sexuality. The contract she entered into with her clothes was always very clear-cut: she was the wearer and never the worn. Her essence, her very Marilyn-ness emanated from the inside out and, for this reason more than any other, her most memorable choices were often the plainest. Marilyn arguably wore an LBD better than anyone before or since, using its monochrome versatility to powerful, sensual effect. This was never more the case than at a 1954 Savoy Hotel press conference to announce her involvement in *The Prince and the Showgirl* (1957), in which she was to co-star with Laurence Olivier. Marilyn attended the event with her then husband, the playwright Arthur Miller, and chose for the occasion a simple black sheath dress, with a sheer panel at the midriff, worn with white gloves and a healthy dose of come hither. According to Hollywood rumour, she and Olivier clashed from the beginning and when, during filming, the starlet agonized over her method acting, her co-star was heard to say, with more than a whiff of irritation, "All you have to do is be sexy, dear Marilyn."

← Backless, strapless, thigh-high… the Little Black Dress has the versatility to be enduringly classic one minute and fleetingly daring the next. Photographed by Nick Knight for the April 2007 cover, wearing her own black lamé minidress design for Topshop, Kate Moss demonstrates that she knows exactly how to harness the power of this wardrobe staple.

As the 20th century entered its second half, a black dress increasingly became the ally of the emancipated woman. Whether she was sashaying down London's King's Road in a little black Mary Quant minidress or making a statement in a zipped and pinned Zandra Rhodes number, she was using it to flaunt her freedom and femininity. As Rhodes herself observed on the eve of the Little Black Dress exhibition at the Fashion and Textile Museum in London in 2008: "A black dress is the best statement piece there is."

If making a statement is a gesture of power, then a Little Black Dress is a powerful weapon in the armoury of the modern woman. Blazing a trail in Zandra Rhodes's wake, Vivienne Westwood was the architect of some of the most eye-catching, risqué Little Black Dresses of her time. Hers was a unique, vampy take on the classic model – slashed, cut and corseted – and with it the punk designer more than fulfilled her aim to sensualize the women who wore her designs because fashion, as she once observed, "is about eventually becoming naked".

A journey through the pages of *Vogue* for the past century of its history shows the LBD conveying a surprising suggestiveness from as early as 1938. Although the long black sequin dress that a model wears in a Horst P Horst photoshoot in the October 1938 issue (see page 86) covers every inch of her body, its figure-hugging power and its very blackness, in fact, imbue the wearer with a vampish sensuality that is breathtakingly modern.

By the Sixties, when the sexual revolution ushered in a less modest attitude to womanhood, clothes became smaller and more revealing. As fashion began to expose more flesh, the LBD shifted radically from demure to daring. A David Bailey photograph of Jean Shrimpton, featured in *Vogue* in November 1965, epitomizes this transition (see page 14). Shrimpton stares, arm behind her head, right into the lens of the camera, the cut-out in the midriff of her little black shift dress, by Nettie Vogues, dares the viewer not to look down from her gaze.

By the Eighties, the *Vogue* woman knew exactly who she was and began to assert her sexual freedom. By the middle of the decade, black seemed to be very much the preferred colour to wear and, in many cases, the less of it the better. Often working in Lycra and leather, designers such as Donna Karan, Azzedine Alaïa and Calvin Klein continually sculpted and sensualized their women. At the same time, a troupe of characterful goddesses, known

simply as "The Supermodels", strutted onto the magazine's pages, all long limbs and powerful attitude. These women – Naomi Campbell, Christy Turlington, Cindy Crawford, Linda Evangelista, Claudia Schiffer, Helena Christensen and the like – were then coupled with glamour-loving photographers such as Herb Ritts, Patrick Demarchelier and Peter Lindbergh. The combination was explosive. A photograph by Herb Ritts in the June 1989 issue of *Vogue*, in which the model stares into the lens in a strapless Little Black Dress slashed to above the thigh (see page 104), perfectly sums up the powerful marriage of beauty, body and black, which prevailed well into the ensuing decades.

In its 21st-century incarnation, the Little Black Dress has found a freedom – like the women who wear it – to be whatever it wants to be. The most marked changes in its impact have been not so much in its shape as in its presentation. Long, short, strappy, flowing – every design angle has, over the decades, been covered. But now, in its modern form, part of the impact of the LBD is the way in which it is worn. This shift is perfectly epitomized by the style icon of our times. Barely a year has gone by since 2000 in which Kate Moss has not appeared on the pages of *Vogue* wearing an LBD. Backless, feathered, lace, leather, skin-tight, thigh-high or diaphanous, these dresses are worn, just as Marilyn Monroe wore hers half a century earlier, with a power emanating from beneath the seams. This is a power that comes from being who you are, and not who you think you should be.

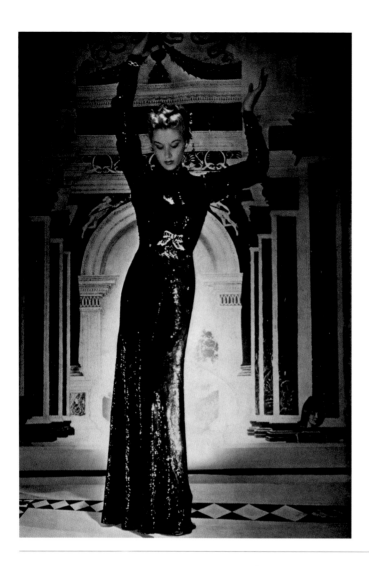

↑ Arguably one of the greatest fashion photographers of all time, Horst P Horst uses careful lighting to emphasize the black-and-white power and beauty of his subject. In this photograph (October 1938), he captures the full drama of Chanel's glittering black paillette sheath by picking out its sequins with spotlights. The caption advises that the dress should be "worn by a woman of great assurance." Although it covers every inch of the model's body, the dress brings with it a potent sensuality borne of her supreme strength and confidence.

→ In this photograph of Claudia Schiffer, taken by Terence Donovan (December 1989), the feminine allure lies in the subtlest reveal of bare neck and décolletage. Although little flesh is exposed in this design by Caroline Charles, it is done so with grace and elegance – proof, if needed, that it is sometimes more alluring to reveal just enough, as opposed to too much.

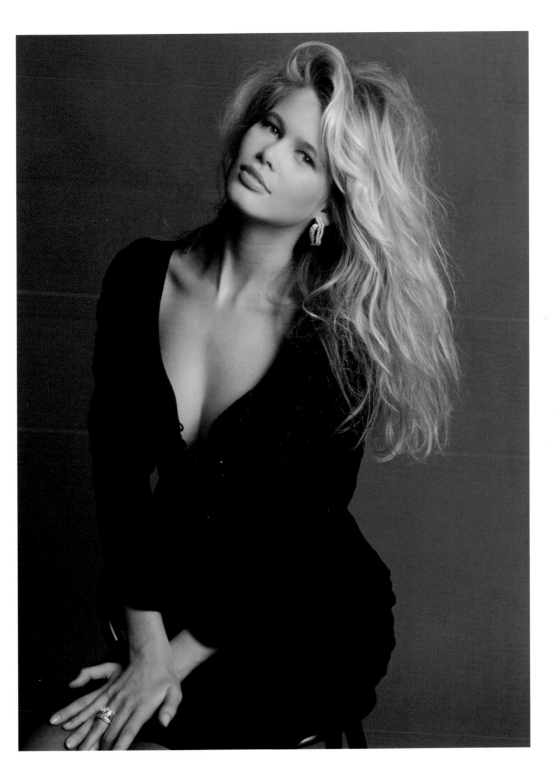

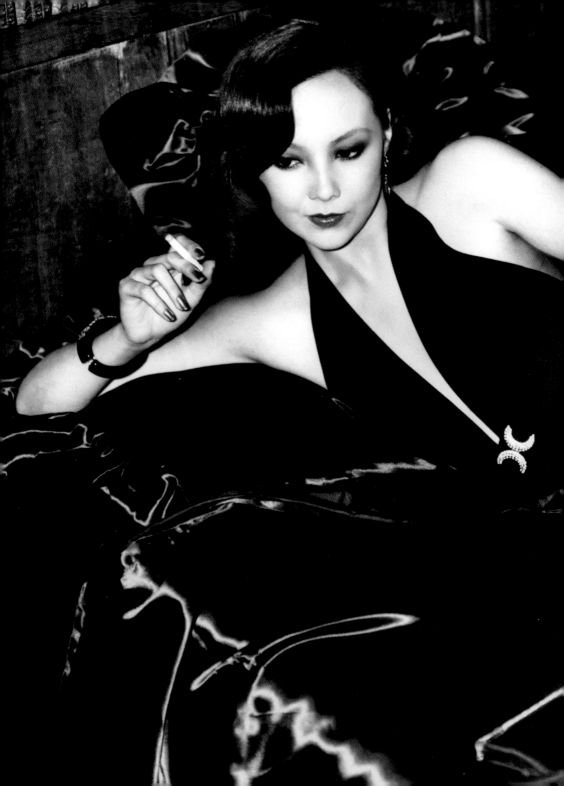

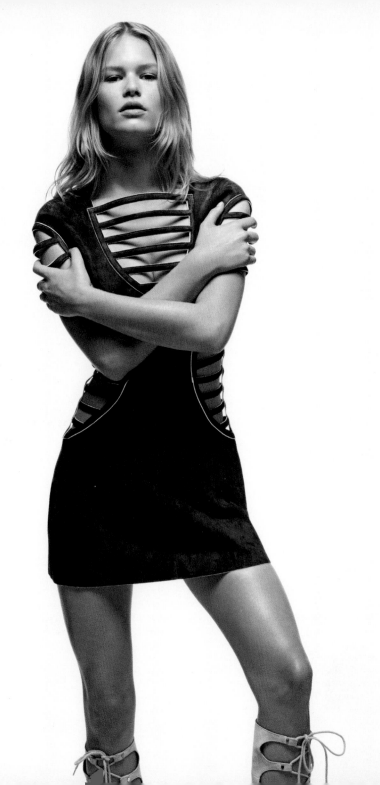

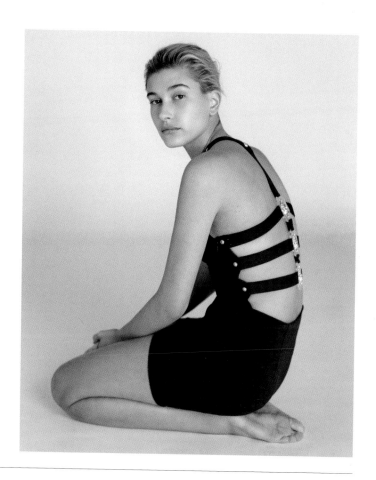

← ← Marie Helvin was one of the most famous models of the Seventies and arguably one of the most sensual. By virtue of her personal relationship with the photographer David Bailey, she produced some of her most impactful work with him. Together, the duo pushed boundaries and in this June 1974 picture, from a story appropriately entitled "Vamp", Helvin sizzles in a black jersey halter dress, clasped at the back of the neck and at the waist with rhinestone crescent moons, by Saint Laurent Rive Gauche. "You only ever see her at night," reads the long, poetic caption. "She hardly exists before 10pm. Her small house is all black velvet and mirrorglass, with a private bar, and a fishtank bath, a hothouse where she grows spotted green orchids... She wears all shades of black, and the Diaghilev colours – fuchsia pink and violet, emerald and kingfisher – and the night scent, Norell."

← "Warrior woman: slashed and exposed, there's a gladiatorial girl set to battle through spring. Play nice." So reads the caption for this photograph from Daniel Jackson's "Fashion i-D" story (February 2015).

Anna Ewers, wearing a black suede minidress by Fendi, stares out at the reader, challenging them not to notice her and feel her strength.

↑ Hailey Baldwin is photographed by Letty Schmiterlow for the story "Hailey's Comet" in the *Miss Vogue* supplement (April 2015). Seated on her haunches, hair scraped back, Baldwin is a natural beauty. Only the jersey Versus minidress, with a strappy reveal at the back, imbues her with a certain knowing. "The body-con returns," announces the caption. "One simple rule? Save gilded detail for the rear view."

← ← For *Vogue*'s centenary issue in June 2016, Mario Testino photographed a seminal "As Time Goes By" story, charting the course of fashion through the decades of the magazine's life. For this mods and rockers-style image for the Sixties, Edie Campbell wears a thigh-high vinyl minidress by Courrèges and wide fishnet tights. "Hike up the hemline and prepare to pout," advises the caption for this photograph, which shows the LBD at its most vampish and rebellious.

↑ Leather and fishnets again, this time in a Josh Olins photograph for his "On the Road" story (August 2015). The model wears a black silk dress with velvet detail, paired with a black leather top, both by Alexander Wang. Tousled hair, dark shadows and a gritty confidence give this 21st-century girl an irresistibly vampish allure.

→ "Saint Laurent's look-at-me leather is the first lesson in how to be a provocateur," reads the caption for this Mert & Marcus photograph, from the story "Kinky Nights" (March 2017). Lily Donaldson wears a black leather dress by Saint Laurent, with crystal jewellery and a tilted captain's hat.

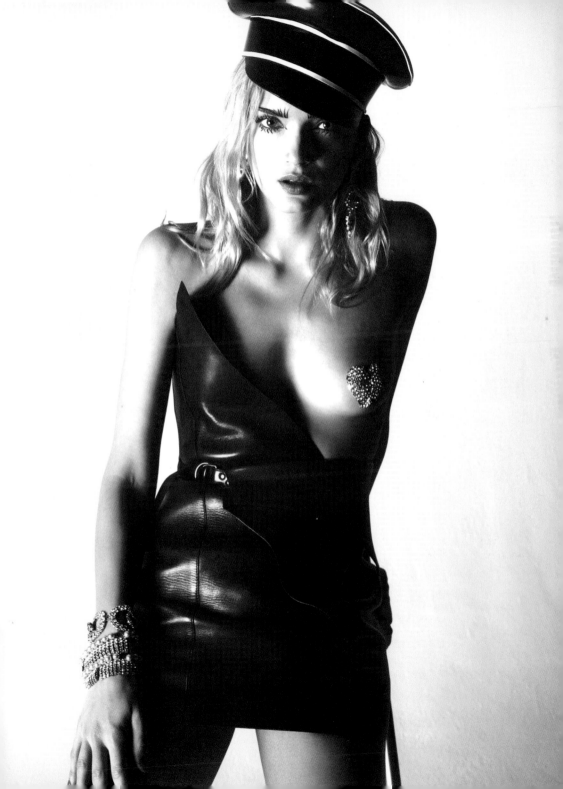

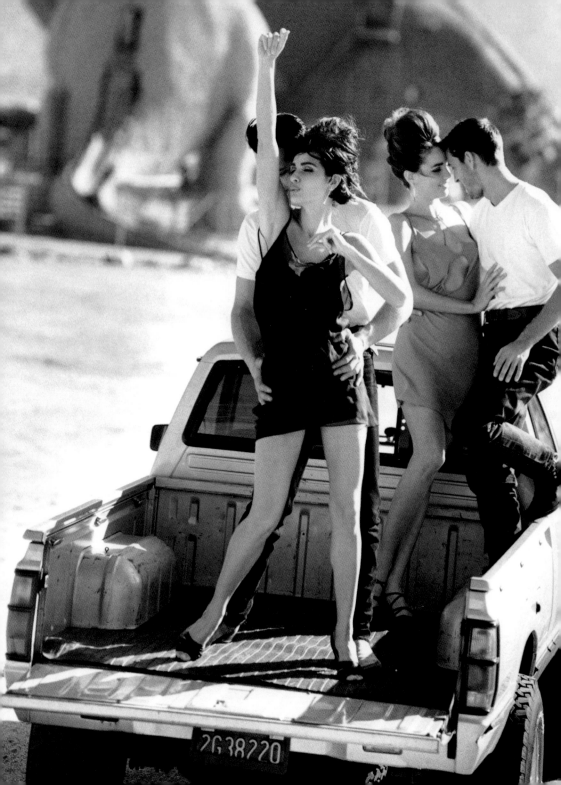

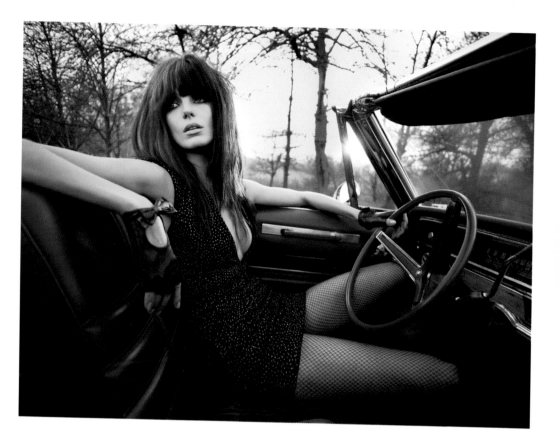

← With their supermodels and big budgets, the images from the Nineties tend to ooze sex appeal. In this May 1991 photograph by Neil Kirk, the model wears two John Galliano slips as one. The accompanying caption says it all: "Tenderly traced across naked shoulders, the shoelace strap gives the shift dress all the delicate sex appeal of lingeries." This type of photograph was very particular to the *Vogue* of the early Nineties,

when it was edited with audacious aplomb by the late Liz Tilberis. It fizzes with the same sort of go-get energy that characterized the era that bore it.

↑ "The race is on to find the season's perfect party dress." "Cause Celebre" was a March 2014 story by Mert & Marcus, which featured a number of new-season party dresses in outdoor locations. In this Chrissie-Hynde-style image,

the model smoulders in a slash-front bouclé mini shift by Heidi Slimane for Saint Laurent. Note the addition of the fishnet tights, scarlet-streaked hair and satin driving gloves with a sweet bow tie that collectively bring the story, and the LBD it features, right up to date.

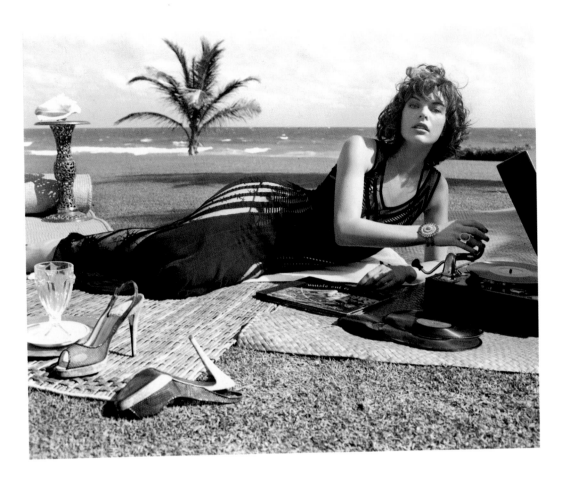

↑ Less is More. Model-turned-actress Milla Jovovich smoulders in this photograph by Carter Smith for his April 2007 "Sea Breeze" story. Wearing a Jean Paul Gaultier tank dress with mesh racer-stripe detail, Jovovich reveals just enough flesh to draw attention to herself but not enough to raise eyebrows. The discarded mesh stiletto mules and empty crystal tumbler tell a tale beyond the picture; the story of a long sunny day, much enjoyed.

→ Lace panelling is once more the order of the day in this October 2013 photograph by Rory Payne in a story entitled "Feeling Plush". The Christopher Kane design is made from black velvet, with lace cut-out criss-cross detailing. Simultaneously erotic and demure, the dress – in true Christopher Kane style – demands to be looked at, at the same time as holding just enough back. "I don't care about good taste or bad taste," says the

Scottish-born designer, whose first fashion memory is of getting in trouble at school for drawing nude figures in his homework. "I can find beauty in anything."

← Kate Moss does it again in this image, shot by Craig McDean for his September 2006 "Shine On" cover story. The dress? A barely-there PVC patent leather dress by Giles, from British designer Giles Deacon – renowned for his humorous, dark, sexy designs. The come hither, unzipped attitude? As ever, all the model's own.

↑ Hot young photographer Josh Olins proves that the back is one of the most alluring erogenous zones in this July 2013 photograph of a strapless satin dress by Jonathan Saunders. Usually awash with colour, Saunders's designs are fresh and modern and always celebrate the femininity of the women who wear them. With this LBD, the look is "the perfect blend of sophistication and seduction".

↑ Yasmin Le Bon wears a shiny black stretch dress with scooped neck and skinny sleeves by Richmond-Cornejo. Andrew Macpherson's photograph for his "Lithe Spirit" story (May 1988) shows that then, as now, the body-con Little Black Dress is about as sexy as it gets.

→ A master in the art of barely-there sensuality, supermodel Cindy Crawford shows that she can rock the allure of the smallest of LBDs like no other. Pictured here in her fortieth year, Crawford wears the sleekest, sexiest Lycra tube dress by Wolford with a Chanel padlock belt for her "Centrefold" shoot with Nick Knight (February 2005). "The body-con trend of the '80s – all second-skin Lycra, micro-minis and plunging tops – is having a revival," reads the caption. "And who better to show it off than the ultimate body beautiful, Cindy Crawford?"

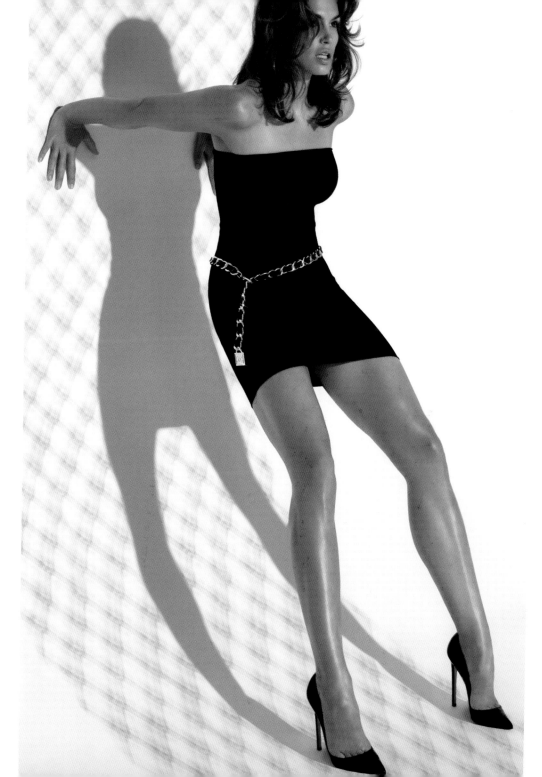

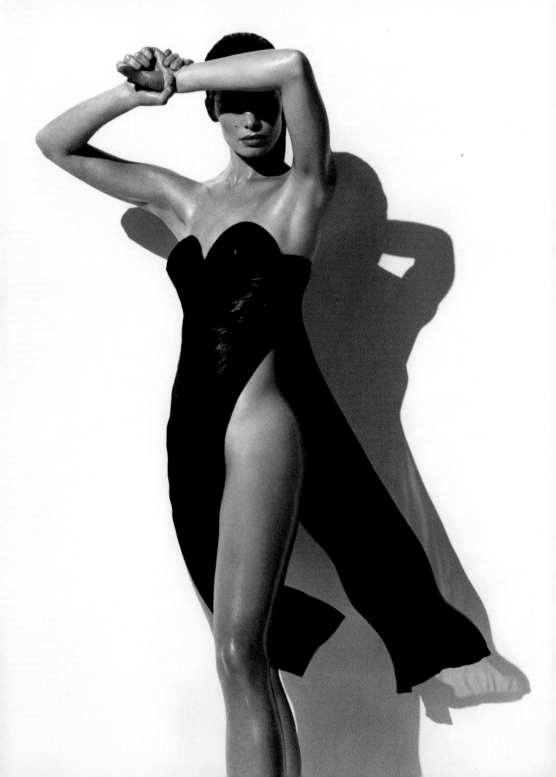

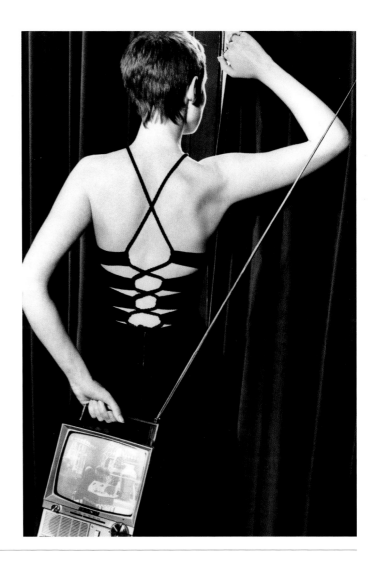

← There is perhaps no better chronicle of the supermodel era than the stark, naturally lit, black-and-white photography of Herb Ritts, a man who, almost more than any other before or since, knew how to put the sensual into fashion photography. In this image from his "Muscle Mechanics" story (June 1989), a statuesque, oiled-up model reveals more than a little flesh in a dramatic black, boned viscose jersey dress slashed to the ribcage, by Jean Paul Gaultier.

↑ "A slender maxi dress by Jean Muir, demure in front with halter neck, but an eye-opener when you spin around – laced with shoe string ribbons all the way to the waist." The beautiful back in this October 1968 image by David Bailey belongs to Grace Coddington, the flame-haired British model who would go on to become one of the most famous fashion stylists of all time, first for British *Vogue* – working under grande éditrice Beatrix Miller – and then for its American counterpart, where she worked with Anna Wintour for 28 years, only stepping down as creative director in 2016, at the age of 74.

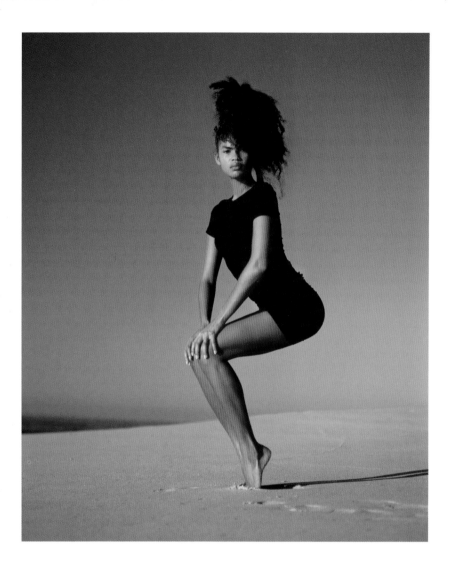

↑ Body-con comes to the fore once more in this image by Patrick Demarchelier (May 1986), featuring a barely-there cotton and Lycra dress by Katharine Hamnett. "What becomes a body most," announces the headline, "the new swim stretch."

→ The cocktail dress gets a new lease of life in seductive silks and satins in this "Shaken Not Stirred" story by Lachlan Bailey (October 2006). A demure bell skirt balances out the more daring racer back on Donna Karan's little black cocktail frock.

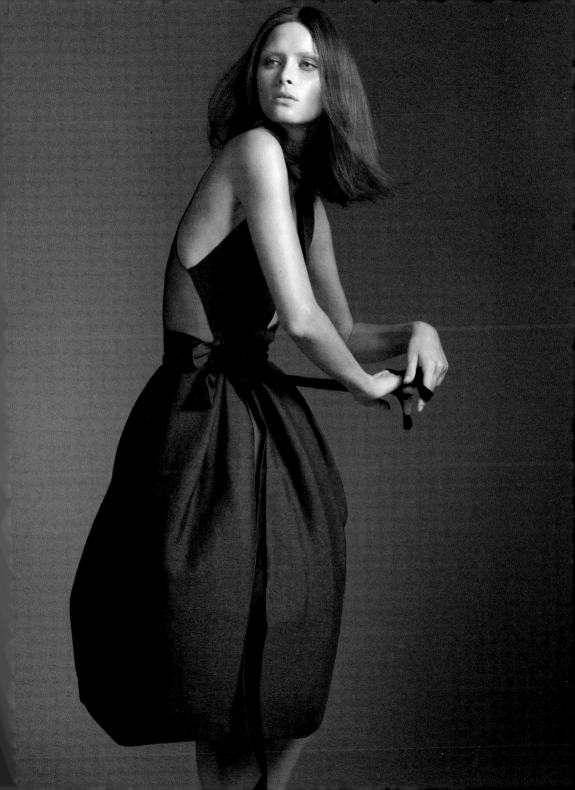

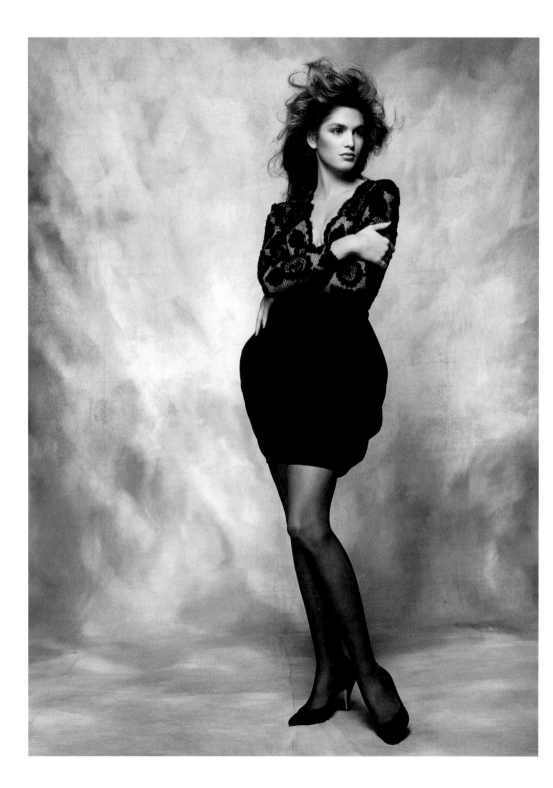

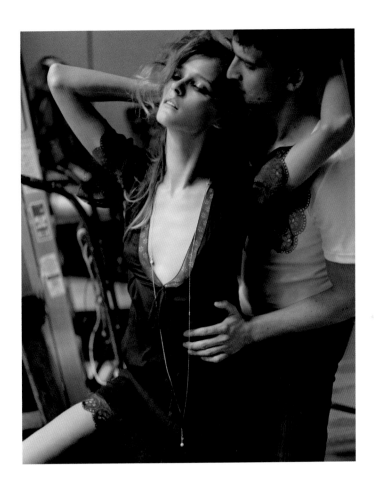

← Cindy Crawford, this time photographed by Terence Donovan (August 1988), illustrates the alluring power of a black lace and velvet LBD, accessorized with acres of leg. The cocktail dress, featuring a skintight, décolleté top, lined in pink silk, and a curved velvet skirt, is by Bruce Oldfield.

↑ Simple meets sexy in Carter Smith's "Unfaithful" story (January 2006), featuring a tousle-haired model in a plunging satin and lace dress by Alessandro Dell'Acqua, accessorized with a long pendant and an amorous attendant.

→ → "Wolf like me: even something as soft as feathers can come with raw, jagged edges." Featuring model Lara Stone, Mario Sorrenti's photograph (September 2014) further sensualizes an already barely-there Alberta Ferretti bustier dress with mud-splattered ravage marks and a real-life wolf.

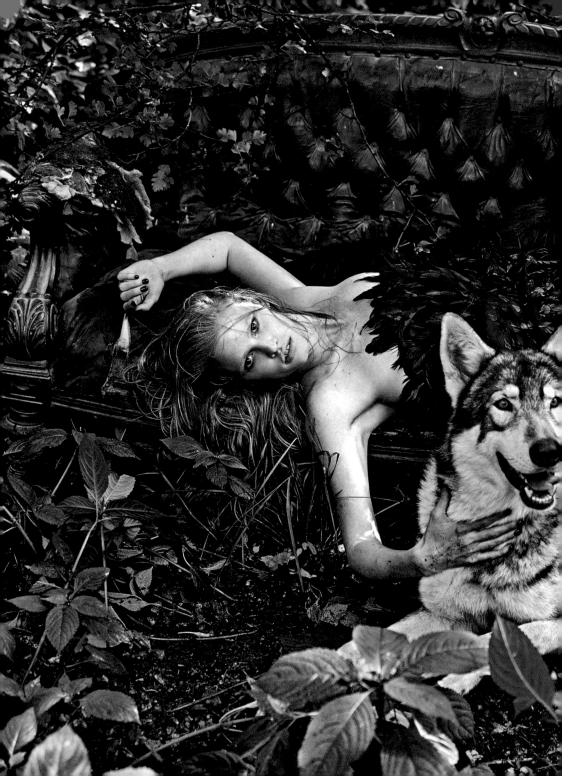

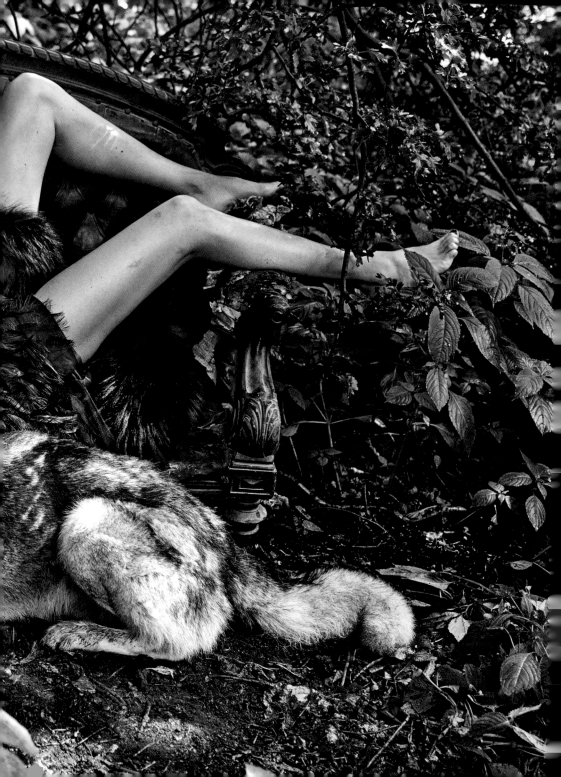

↑ As long ago as 1957, fashion designers and photographers alike were harnessing the power of the LBD. In this Henry Clarke image (October 1957), Julian Rose's harem sheath dress – the caption draws the reader's attention to "its brand-new shortness" – reveals a square, décolleté neckline harnessed with two enormous bows. But it is the look of the model that says it all, staring over her shoulder into the lens, coolly and calmly holding her own.

→ It would be hard to find a littler Little Black Dress than this Karl Lagerfeld design for Chanel, photographed by Dewey Nicks (April 1994). But it is not just the abbreviated nature of the lace-tiered shift that winks at the reader; it is also the model's long black lace gloves, tousled hair and come-hither stare.

modern
twist

From its very conception, there has been a refreshing modernity to the Little Black Dress, and this has continued throughout its lifespan. It is largely for that reason that, historically, young photographers setting out to make their mark on the world of fashion have been drawn to its revolutionary charms. Cecil Beaton embraced it with aplomb, unsurprising considering his mantra: "Be daring, be different... be anything that will assert integrity of purpose and imaginative vision against the play-it-safers, the creatures of the commonplace, the slaves of the ordinary." A young David Bailey, working some 25 years later, all but claimed the LBD for his own, while the bright young things – the likes of Helmut Newton, Terence Donovan and Willie Christie – all clamoured to photograph it in their own best light.

One of Newton's photographs from April 1966 stands out in particular. A girl in a barely-there LBD flashes across the page on a racing bike (see page 133). The clean modernity of the image is thrilling, which is created not so much by the dress itself as by the context. And this is, of course, the real visual appeal of the Little Black Dress: for innovative young photographers with something new to say, an item of clothing renowned, above all else, for its versatility becomes the perfect tool.

Under its formidable editor Beatrix Miller, *Vogue* enjoyed a golden age between the years of 1964 and 1985. It was Miller who introduced the "Young Ideas" pages, an early example of which shows a thoroughly modern Twiggy in a little black minidress, as photographed by Newton in April 1967 (see page 118). As the

← Ever since it broke the fashion mould in the Twenties, the LBD has been characterized by its modernity – its ability to shift shape through times, eras and fashion movements yet still retain its pertinence. In Mario Testino's "Seduced by the Dark Side" story (August 2005), shades of black pop out against a vibrantly colourful Portuguese backdrop. Here, a silk taffeta Yves Saint Laurent dress with bloomers has a breathtakingly modern and vertiginous *Alice in Wonderland* effect.

years progressed, some of the most exciting names in fashion photography were added to the LBD's dance card: Guy Bourdin, Eric Boman and Barry Lategan all staged several attempts to show it at its best.

Never one to fade into obscurity, the LBD was consistently reinvented over the years by fashion designers who were also keen to make their innovative mark. Looking closely at a Lothar Schmid image of a Zandra Rhodes ripped, torn and chained LBD against a ripped, torn electric blue background in the September 1977 issue of *Vogue* (see page 143), one is struck by the modernity of the complete package of model, dress and context.

A rite of passage for most designers, the LBD become a fixation for some. For Azzedine Alaïa, a couturier whose roots lay in architecture, it was an art form he felt he never quite mastered. "I like black, because for me it is a very happy colour," he said. "For me, perfection is never achieved, so you need to go on working."

It is astonishing, sometimes, to see the possible variations on the Little Black Dress, and to comprehend how extraordinary it is that something so simple can have such a complex array of incarnations. With the arrival of the 21st century, the LBD – which had spent a large part of the Eighties and Nineties in its simplest, purest form – began to take on a more radical guise. In the work of photographers such as Nick Knight, art and fashion began to blend seamlessly together, and the Little Black Dress found its place at the heart of this transition in the studio. Meanwhile, the likes of Mario Testino and Laurie Bartley took the LBD on location and used it to enhance its surroundings. In Testino's photograph from the August 2005 issue of *Vogue*, the dramatic backdrop is rendered twice as exciting by the Yves Saint Laurent LBD in the foreground (see page 114).

With the advent of the computer age, digital retouching has made the LBD an indispensable ally of the creators of fashion imagery. What better way to draw the eye to a magical context than with a neatly structured black dress? Take Tim Gutt's December 2010 image of a model balancing on a tightrope between two high-rise buildings (see page 137). Nothing about this photograph is real, apart from the girl who is its subject, and our eye is drawn instinctively to her by the fact that she is dressed in black. In many ways, it is her hyperreality that allows us, encourages us even, to buy into the fantasy.

As fashion photography continues to push against the boundaries of its own reality, it is not just the fashion designers who need to move with them. The unsung heroes of fashion photography, the stylists who work with these photographers have also had an integral role to play in the constant reinvention of the Little Black Dress. Whether it's Francesca Burns putting a large, red leather rose choker around a model's neck for Angelo Pennetta in August 2016 (see page 123), or Kate Phelan pairing an LBD with knee-length socks and kitten heels for Daniel Jackson in September 2011 (see page 156), stylists, along with the other behind-the-scenes hair and make up creatives, deserve full credit for constantly evolving the images being created on the pages of *Vogue*.

More often than not, the impact of an image is achieved by the tiniest details – the Japanese lettering on Carven's LBD, as featured in Oliver Hadlee Pearch's April 2015 *Miss Vogue* supplement shoot (see page 136), or the bowl haircut and sinewy torso of the model, Edie Campbell, chosen by David Sims for his April 2013 story (see page 132). To truly modernize, one needn't do anything radical. Simply move forward, slowly and steadily, with the times, pushing the boundaries little by little, with the help of a timeless classic. After all, what, in the end, could be more modern than a fresh acknowledgement of a perfect past?

↑ The "Young Ideas" pages by *Vogue*'s fashion editor Marit Allen in the Sixties were some of the freshest and most innovative that the magazine had ever seen, featuring affordable clothes for a new, fashion-savvy generation. Photographed by Helmut Newton (April 1967), model of the moment Twiggy is wearing a Biba deep black "tragedy dress" with golden edging, a "Mary, Queen of Scots" square neck, short sleeves and the shortest of skirts.

→ In this image from March 1977, the model wears a beautifully simple Jean Muir matte jersey dress with a low Peter Pan collar, thin belted waist and inverted pleat on the front of the skirt. Grace Coddington's fashion photographer husband, Willie Christie, manages to make the dark dress pop out against a vibrant fizz of background colour, making it feel fresh and new.

← There is a refreshing simplicity to this pared-back Josh Olins image (July 2010) of a silk asymmetric shoulder dress by Giorgio Armani that makes it feel utterly contemporary. "Please note," reads the accompanying caption. "No jewellery with a dress as flattering as Mr Armani's, why overload?"

↑ Assymetric once again, this time in a black satin design by Yves Saint Laurent Rive Gauche, as photographed by Tom Munro (November 1998). There is something timeless about a one-shouldered sliver of black – a Grecian chic that has endured across the decades and will surely continue to do so.

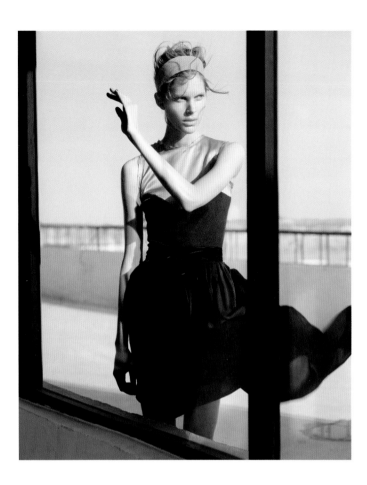

↑ Behind a pane of glass, glamour and innocence combine in Lanvin's cotton-velvet and satin minidress, as photographed by Laurie Bartley for his "Dressing Up" story (August 2005). Simultaneously timeless and modern, the image gently fixes itself in the mind.

→ Devon Aoki is the star of this story by Harley Weir (August 2017), entitled "The Wilds". Photographed outdoors, with a red leather rose choker at her throat, Aoki wears a silk and lace slip dress by Anthony Vaccarello for Saint Laurent. The effect is otherworldly and somehow outside time.

→ → For his "New York's Finest" story (August 2016), Angelo Pennetta introduced designer clothes to de-glamorized locations, juxtaposing the expensive with the affordable in a fresh take on the classics. Two Dolce & Gabbana LBDs – one in wool crepe, the other draped silk tulle – are taken out to eat in downtown Chinatown.

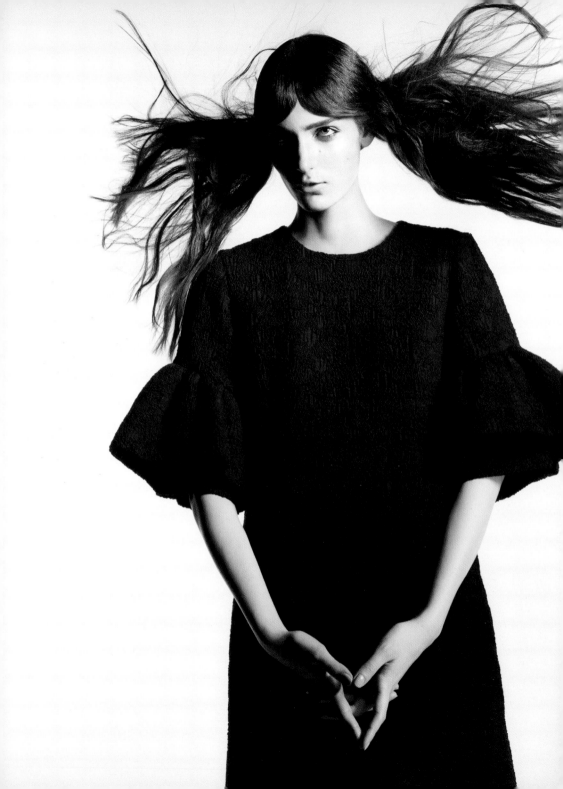

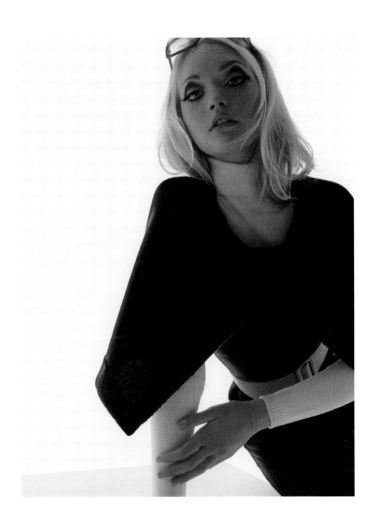

← At first glance, it is strangely hard to date this March 2012 image from David Sims's story "The Finest Line". It could be then and could be now. The model wears a black brocade dress by Dries Van Noten. "Sometimes a suggestion of volume is enough to add interest," reads the accompanying caption. "Here, gently puffed sleeves get the message across".

↑ Similarly, this September 2006 image by Nick Knight, from a story entitled "The Smart Set", looks exactly like a still from the Sixties. In it, the model – in heavily lined eyes and powder-pale lips – wears a black wool sweater dress and cape by Givenchy, and stares into the camera from both the past and from the present. The cream polo-neck sweater by Jil Sander and glasses from Cutler and Gross only add to the vintage effect.

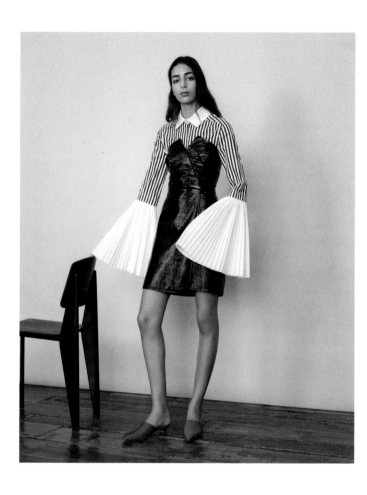

↑ In this photograph by Ward Ivan Rafik (March 2017) for the "*Vogue Shops*" pages, an inexpensive strapless black dress from River Island is paired with a striped shirt with dramatic statement sleeves from Monographie, to modernizing effect.

→ Patrick Demarchelier's career has spanned the best part of 40 years. In this photograph from December 2009, he features a modern silk-faille shirtdress by Oscar de la Renta in an antiquated light. With a ripple of ruffles, skinny arms and a gently belled skirt, the dress spans the ages with its references to a luxurious past and a timeless future.

→ → There is a space-age feel to this Alasdair McLellan image from his "Full Throttle" story (September 2016). Wearing a black, flute-sleeved leather minidress by Ralph Lauren Collection, model Edie Campbell is surrounded by dirt-bike riders, which assume an alien-like effect.

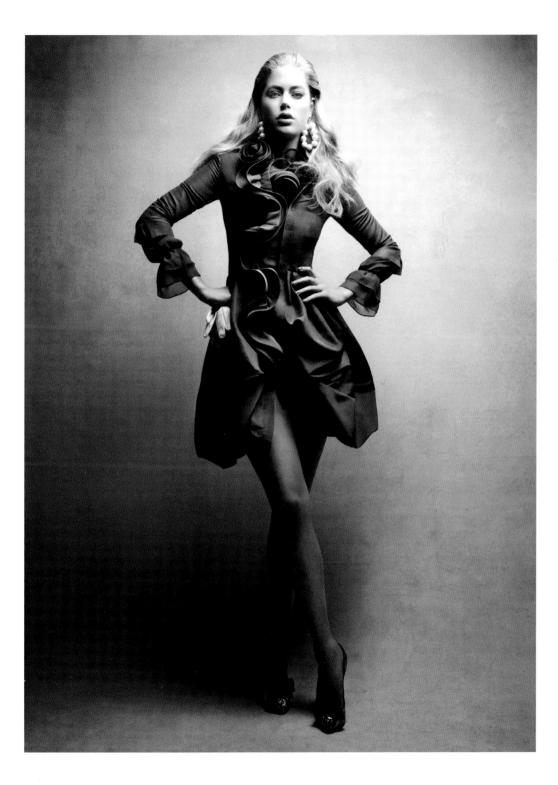

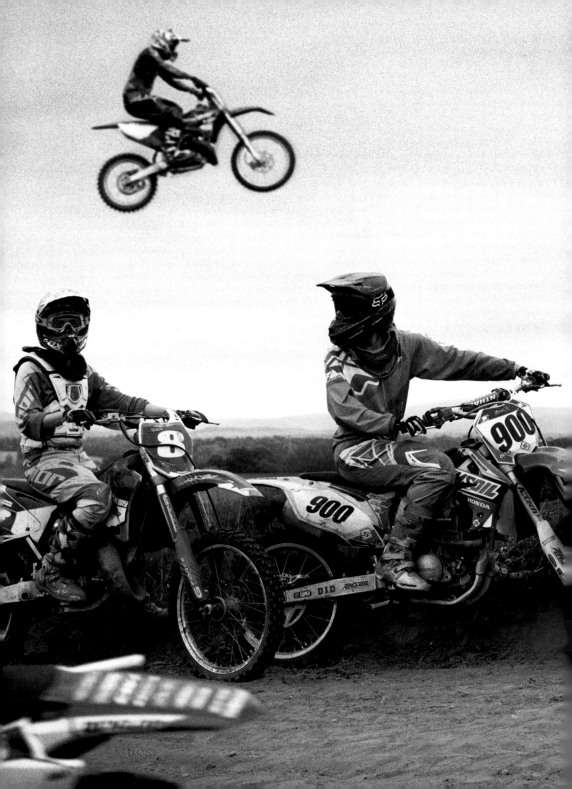

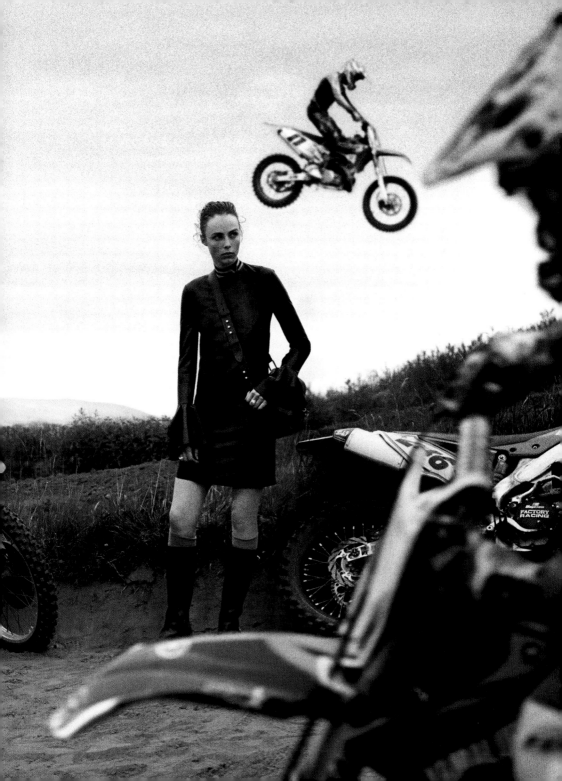

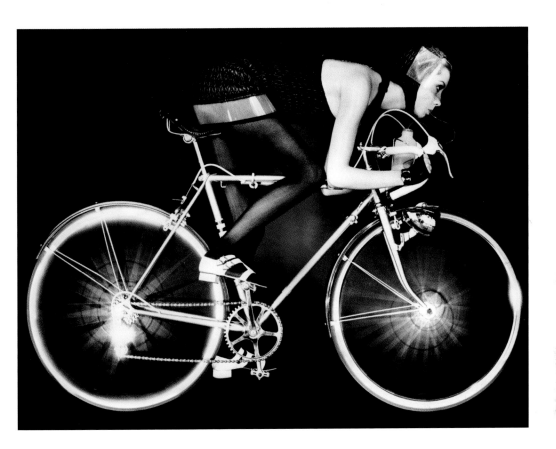

← David Sims photographs model of the moment, Edie Campbell, in a timeless, asymmetric look by Balenciaga for the April 2013 issue. "Nicolas Ghesquière exits with a final fashion twist: non-girly ruffles" reads the accompanying caption. "Try a sharp dorsal-fin frill over cropped trousers, and add studious box-heel Oxfords."

↑ From the moment he emerged on the fashion scene in the late Fifties, the photographer Helmut Newton pushed boundaries. In this radically original photograph from the April 1966 issue, Newton showcases a tiny Little Black Dress by John Bates for Jean Varon on a speed bike.

→ → There is a timeless beauty to this photograph taken by Cedric Buchet for his "Wild Shores" story (November 2007). Wearing a wool-cashmere sweater dress with quilted trim detail by Burberry Prorsum, the windswept model looks into fashion's future.

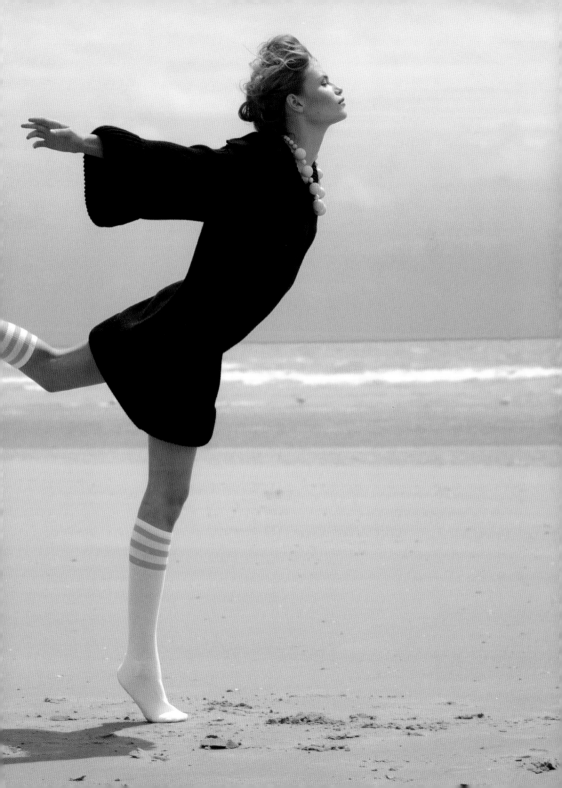

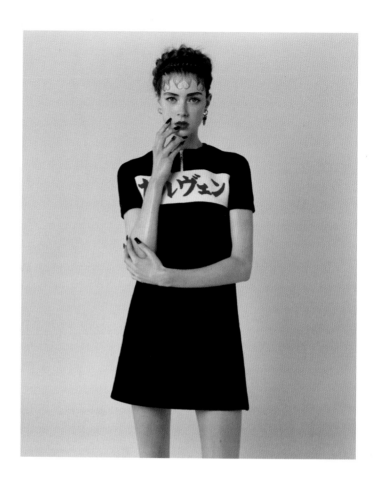

↑ What could be fresher, or more modern, than this plain black cotton dress with Japanese writing? Designed by Carven, a label which effortlessly combines the decadent finesse of haute couture with a fresh, contemporary twist, this dress is modelled by the young face of the moment, Jessica Burley. Oliver Hadlee Pearch captured this image for the story "Scene Stealer", for the April 2015 *Miss Vogue* supplement.

→ The digital revolution in fashion photography has opened up an exciting new visual world on the pages of *Vogue*. In this Tim Gutt image from December 2010, a simple wool, leather and stingray-skin dress by exciting London-born knitwear designer Louise Goldin is made into something magical by its dawn high-wire context. The Libra entry for Gutt's "Star Signs" zodiac story, styled by Kate Phelan with sets by Shona Heath,

this photograph was one of just 12 extraordinary images, which also featured model Siri Tollerod in an oversized shell for the Cancer entry and in the thrall of a white-cloud stallion for Capricorn.

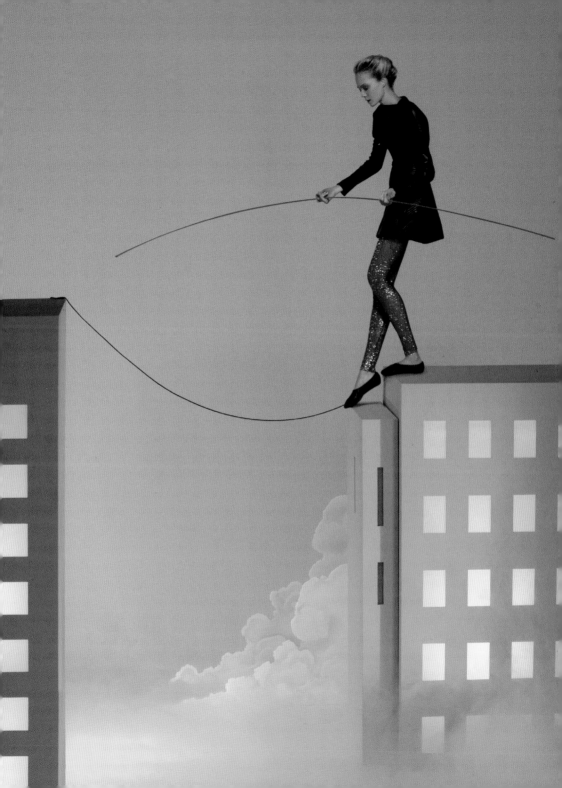

← By accessorizing a cotton mesh dress with a pair of black leather biker gloves, worn by Lily Donaldson, Lachlan Bailey keeps pushing forward for the March 2011 issue in a sports-themed story entitled "Good Sport". "Take home the trophy in Bottega Veneta's sheer-panelled dress," reads the caption.

↑ Bottega Veneta again, this time in Swedish-born fashion photographer (and director) Mikael Jansson's September 2008 story, "The Edge of Elegance". In this clean, stylish image, cut-away shoulders and a funnel neckline give a black wool dress a haute-futuristic edge, with the effect enhanced by bold, punkish hair and heavy, impactful eye make up.

↑There is a contemporaneity to black leather that is hard to match. For his "Coming Clean" story (November 2012), Karim Sadli photographs a leather shift dress by Michael Kors in a pared-back studio setting. "As comfortable as an oversized T-shirt," reads the caption. "Michael Kors's leather dress spells freedom; ideal for the woman who likes to move in her clothes."

→ As fashion technology evolves, so, too, does the Little Black Dress. The boundary-pushing photographer Guy Bourdin uses a simple black ciré dress by Georgina Linhart to form the centrepiece of his "Shine and the World Shines with You" story (March 1969).

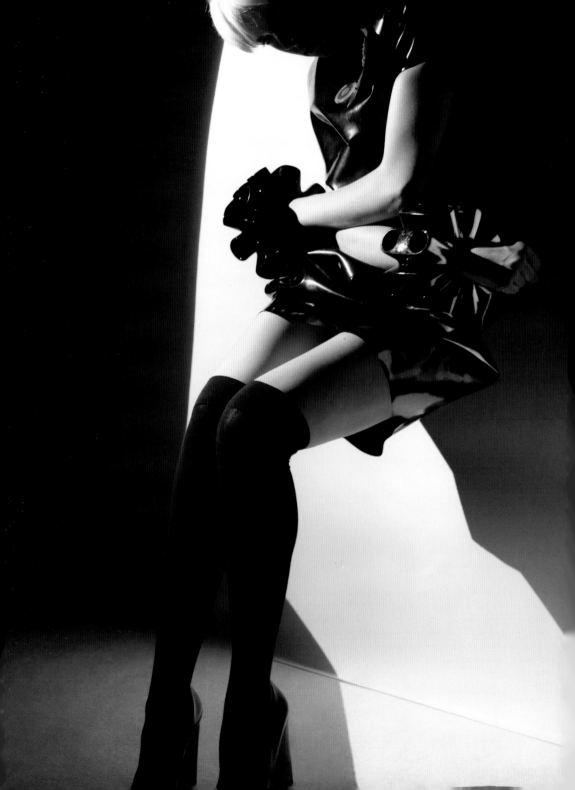

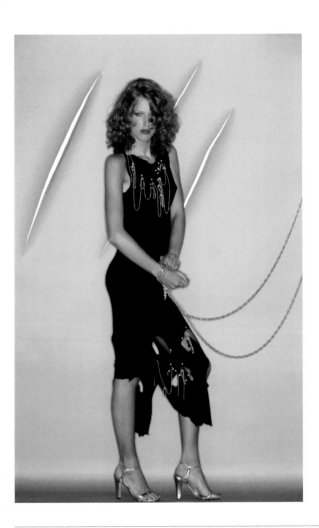

← A PVC dress by Marni takes centre stage in Nick Knight's October 2007 "Light and Shade" story. A monochromatic feast, with no sense of an ending, the image is bold and stark. Staring directly into the camera, with her hands curled into fists, the model is defiant. "The chicest camouflage," reads the accompanying caption. "Hardware touches and soft folds make a modern match."

↑ "Zhandra Rhodes's jersey – ripped, slashed and blue stitched into her personal view of punk. She calls it conceptual chic." A tirelessly enthusiastic ambassador for the Little Black Dress, Rhodes's "mean streak of black jersey with blue cotton stitching, chain, ball bearings, safety pins and random diamonds" feels as modern and exciting as it is possible to feel in this image by Lothar Schmid (September 1977).

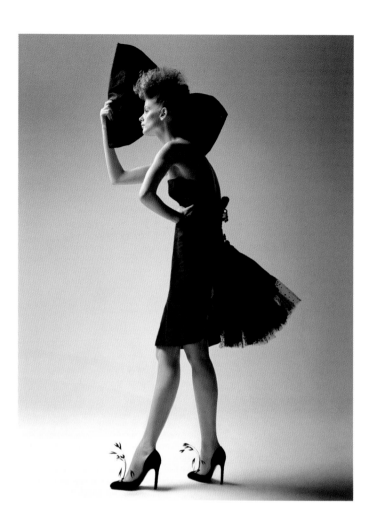

↑ The black strapless taffeta dress with polka dots by Valentino Haute Couture, photographed by Patrick Demarchelier for his "From Paris with Love" story (October 2005), has a beautiful, timeless quality to it, as if it were suspended in the studio half-light.

→ In this photograph by Nick Knight for the story "The Clothes That Changed Our Lives" (December 2006), Kate Moss appears as a spectre of visionary beauty modelling a grosgrain Little Black Dress with bustle by Marios Schwab.

→→ For his story "As Time Goes By" (June 2016), Mario Testino pays homage to Forties fashion photography. He takes a wool and velvet dress by Prada, modelled by Jean Campbell, as the centrepiece and breathes 21st-century life into wartime style.

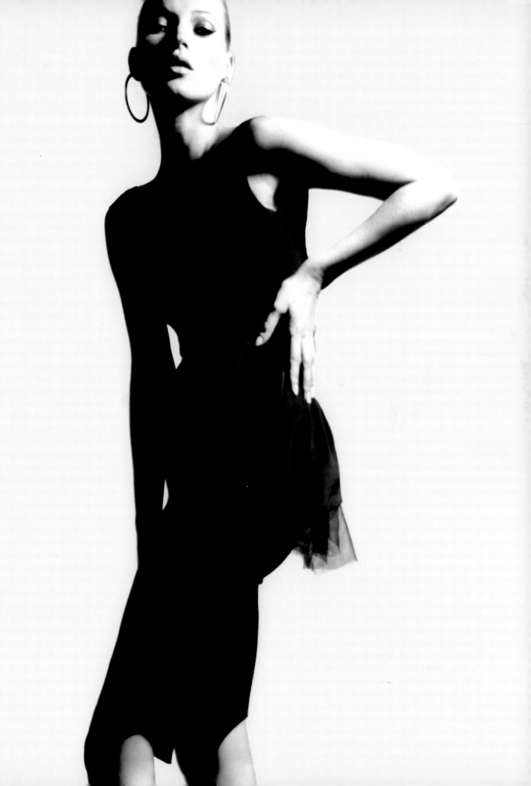

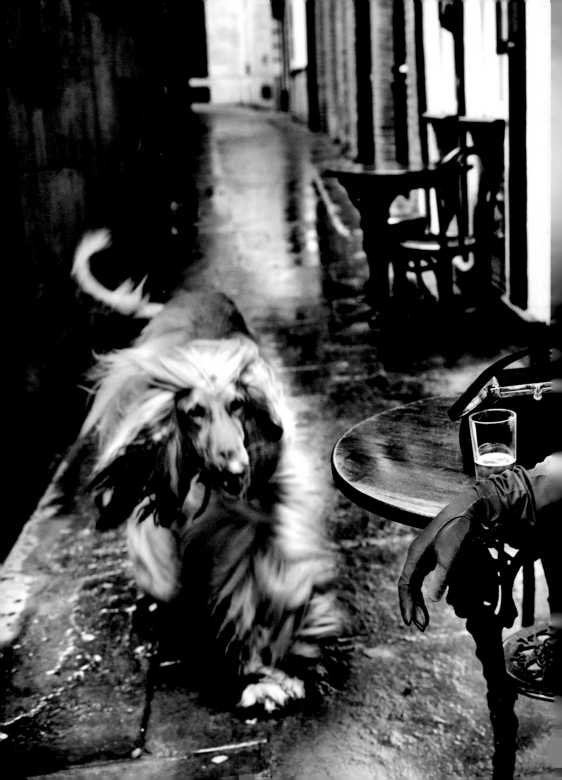

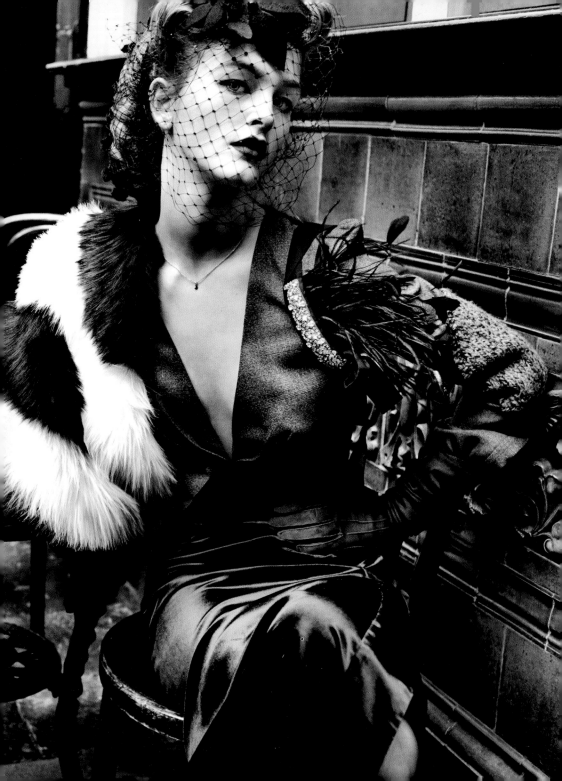

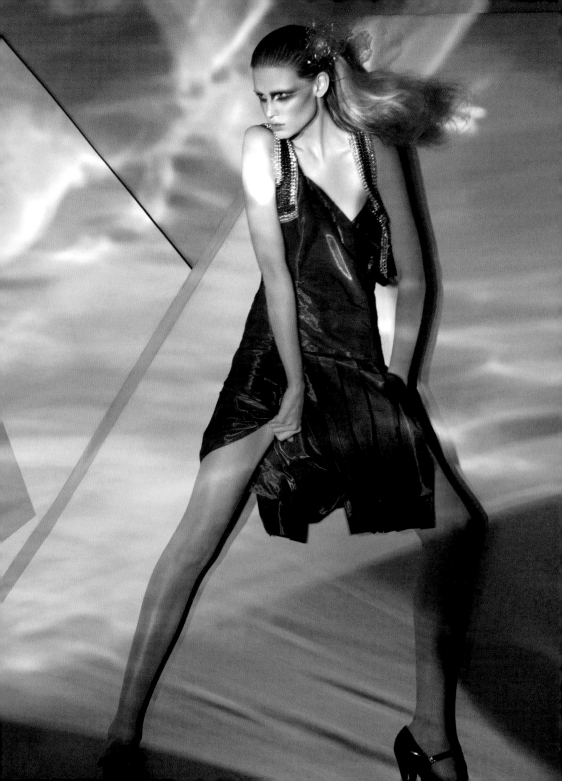

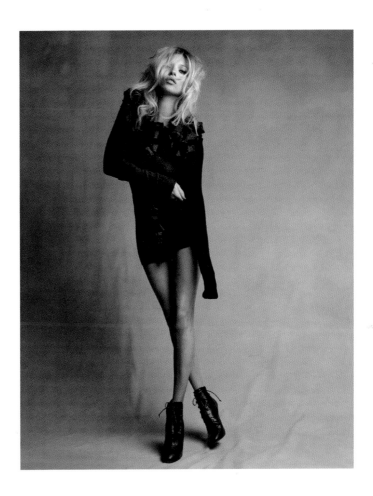

← Craig McDean's photography boasts a new-age modernity – a flash of fresh inspiration for the 21st century. For the "New Order" story (March 2007), the model wears a coated-nylon drop-waisted dress by Pringle, to create a look of space-age chic.

↑ For his photographic celebration of Kate Moss, entitled "The Moss Factor" (September 2010), Patrick Demarchelier captures the most super of supermodels in a silk-crepe and tulle minidress by Bottega Veneta, styled by Kate Phelan. The end result is simple and beautiful; modern in its pose, timeless in its glamour.

→ → "Strict, slit and sublime, welcome the new status little black dress." This lace dress with silk jersey collar by Prada is the ultimate 21st-century incarnation of a timeless classic: machine-made structuring, enhanced by silver platform heels and classic red lips. Javier Vallhonrat's photograph from September 2008 is part then, part now; part present, part forever.

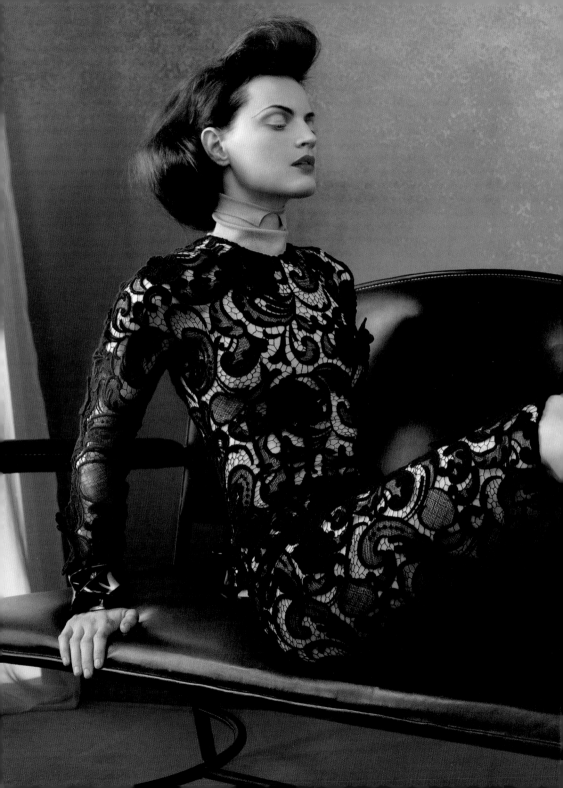

↑ Leather strikes a fashionable
pose in this photograph by Dario
Catellani for his "Strike a Match"
story (August 2017). The leather
wrap dress by Proenza Schouler
is brought strikingly up to date by
a seemingly backward-looking
addition of a vintage-style hat,
gloves and bag.

→ Stella Tennant models
Valentino's filmy halterneck LBD,
embellished with tiny ruffles and
an intricate lace trim, for Mario
Testino's "Hot Couture" story
(April 1997). "A light touch gives
a dream-like delicacy to Valentino's
finest confection." The undertone
of red light, picked out in the
Manolo Blahnik heels and the silk
flowers by Flowers by Novelty,
bathes the photograph in a
modern glow.

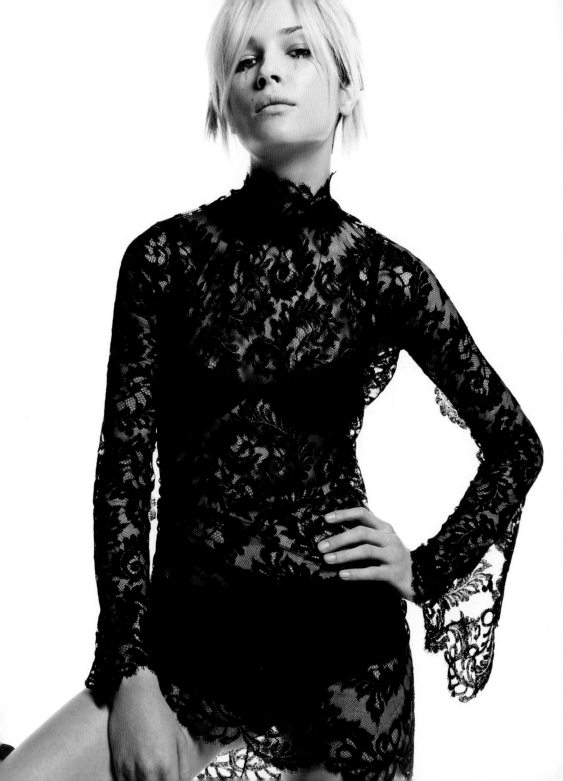

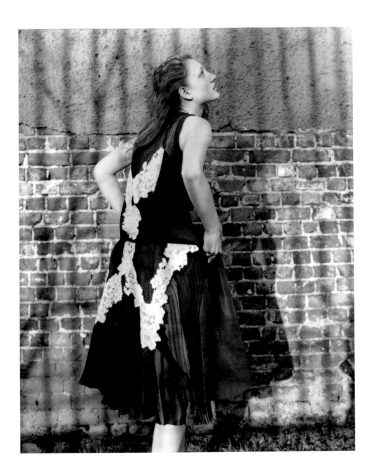

← "Stop, Look, Listen" was the title of this August 2001 fashion story by Tom Munro. In this particular photograph, Dolce & Gabbana mix a high-neck sheer lace minidress with sheer seduction. The vintage appeal of the lace juxtaposes perfectly with the modern cut of the attitude, showing that, for all their unparalleled instinct for classic glamour, the Italian fashion-design duo always have an eye keenly focused on the now.

↑ Harely Weir introduced an otherworldly quality to the pages of *Vogue* with this May 2016 story, "Earth Angel". Here Sacai's black, navy and yellow pleated chiffon and lace dress has a Victoriana modernity to its soft lines. Note how the delicate femininity of the lace detailing juxtaposes impactfully with the harder, shadowy lines on the exposed brick wall behind.

↑ In Daniel Jackson's September 2011 story, "The Beat Goes On", styled by Kate Phelan, a Versace wool pinafore dress is perfectly modelled by a young woman in knee-high socks. This image is accompanied by a simple caption: "Take knee-high socks and pull skinny sleeves up by just a few inches; these clever styling tricks have proved to have the power to elongate limbs."

→ For his September 2016 "Figure Study", acclaimed fashion photographer and director Glen Luchford proves that what goes before will come again. Photographed in a cloud of chiffon, the black hooded leather minidress, designed by Anthony Vaccarello, has a timeless, ethereal beauty, an untouchable elegance which, like the LBD itself, has moved through the decades and shows no sign of diminishing.

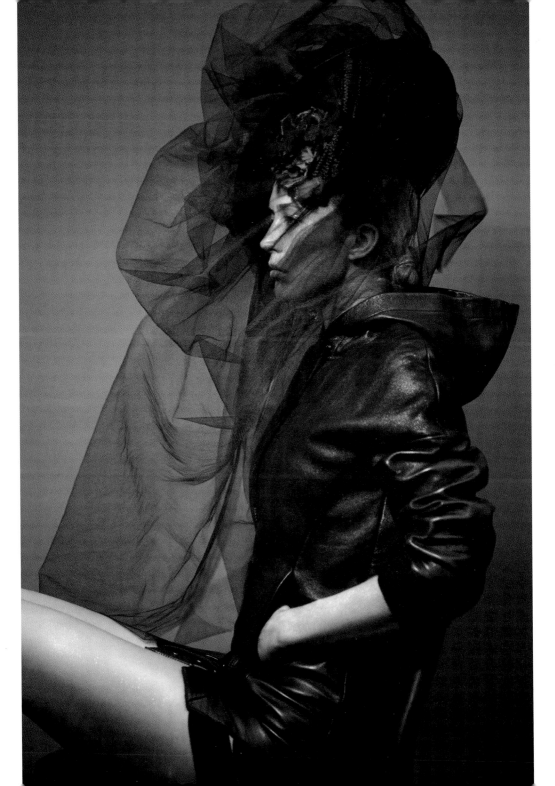

index

acknowledgements

An Hachette UK Company
www.hachette.co.uk

First published in Great Britain in 2018 by
Conran Octopus Ltd,
a division of Octopus Publishing Group Ltd
Carmelite House, 50 Victoria Embankment
London EC4Y 0DZ
www.octopusbooks.co.uk
www.octopusbooksusa.com

Text copyright © The Condé Nast
Publications Ltd 2018

Design & layout copyright © Octopus
Publishing Group Ltd 2018

Distributed in the US by Hachette Book Group:
1290 Avenue of the Americas, 4th and 5th
Floors, New York, NY 10104

Distributed in Canada by Canadian Manda
Group: 664 Annette St., Toronto, Ontario,
Canada M6S 2C8

ISBN 978 1 84091 765 9

A CIP catalogue record for this book
is available from the British Library.

Printed and bound in China

10 9 8 7 6 5 4 3 2 1

Publisher: Alison Starling
Creative Director: Jonathan Christie
Junior Editor: Ella Parsons
Copy Editor: Helen Ridge
Senior Production Controller:
 Allison Gonsalves

Special thanks to Harriet Wilson, Brett Croft,
Poppy Roy and Frith Carlisle at The Condé
Nast Publications Ltd.

Every effort has been made to reproduce
the colours in this book accurately;
however, the printing process can lead
to some discrepancies.

Unless otherwise stated, all text and
photographs are taken from British *Vogue*.

All photographs The Condé Nast
Publications Ltd except the following:

p2 © Norman Parkinson Ltd / Courtesy
Norman Parkinson Archive; pp26–27 © Nick
Knight; p31 © Mario Testino; p33 © Inez &
Vinoodh; pp34–35 © Mario Testino; p39 ©
Alasdair McLellan; p43 © Mario Testino; p58
© Angelo Pennetta; p65 © Peter Lindbergh;
p67 © Nick Knight; p68 © Norman Parkinson
Ltd / Courtesy Norman Parkinson Archive;
p73 © David Sims; p76–77 © Mario Testino;
p78 Javier Vallhonrat; p79 © Norman
Parkinson Ltd / Courtesy Norman Parkinson
Archive; p82 © Nick Knight; pp92–93 ©
Mario Testino; p94 © Josh Olins; p95 © Mert
& Marcus; p97 © Mert & Marcus; p100 ©
Craig McDean; p101 © Josh Olins; p103 Nick
Knight; pp110–111 © Mario Sorrenti; p114 ©
Mario Testino; p120 © Josh Olins; pp124–125
© Angelo Pennetta; p126 © David Sims; p127
© Nick Knight; pp130–131 Alasdair McLellan;
p132 © David Sims; p142 © Nick Knight; p145
© Nick Knight; pp146–147 © Mario Testino;
p148 © Craig McDean; pp150–151 © Javier
Vallhonrat; p153 © Mario Testino; p157 ©
Glen Luchford.

Page 2: "Deep and wide curving neckline,
slender skirt and brief sleeves: simple lines
for a timeless, ubiquitous dress," said
Vogue of this startlingly modern image
from November 1957 – a casual look for
late day – by the celebrated photographer
Norman Parkinson. "The story is in the
fabric, a winter-loving black jersey whose
softly curled surface masquerades as
Persian lamb." Of particular note is the use
of accessories to make this simple, sculpted
dress sing: hat, belt and handbag, and dark,
standout make up shades.

Page 4: For the cover of the June 2002 issue,
Corinne Day's signature brand of pared-back
fashion photography sees a fresh-faced
Gisele Bündchen staring out at the world
in a cotton mesh LBD with lace detail by
Versace. With scraped-back hair and her
face almost totally devoid of make-up, she
is a picture of serenity. The minidress itself,
barely there and hugely revealing, ironically
only serves to highlight this simplicity. With
seemingly so little, the photograph seems
to say so much, not least about the iconic
nature of the LBD, which, more than any
other wardrobe staple of its kind, always
manages to draw attention to itself
without ever shouting loudly.

CHLOE FOX is a contributing editor to *Vogue*,
where she spent three years working on
the Features desk. Over the years, she has
interviewed a number of its cover stars,
including Sienna Miller, Keira Knightley
and Helena Bonham Carter.